**The Designer's
Dictionary of Color**

The Designer's Dictionary of Color

by Sean Adams

Foreword by Jessica Helfand

ABRAMS, NEW YORK

© 2017 Quarto Publishing plc

For Quid
Text and design: Sean Adams
Editor: Lucy York
Picture Researchers: Katriona Feinstein, Simona Stabados

For Abrams
Editors: John Gall and Ashley Albert
Design Manager: Devin Grosz
Production Manager: Alex Cameron

Library of Congress Control Number: 2016949082

ISBN: 978-1-4197-2391-9

The principal typeface used is Sentinel, designed by Jonathan Hoefler and Tobias Frere-Jones in 2009. Sentinel is based on earlier Egyptian or Slab Serif typefaces such as Clarendon designed by Robert Besley in 1845.

The color swatches contained in this book are as accurate as possible. However, due to the nature of the four-color printing process, slight variations can occur due to ink balancing on press. Every effort has been made to minimize these variations.

PANTONE Colors displayed here may not match the PANTONE-identified standards. Consult current PANTONE Color Publications for accurate color. PANTONE® and the PANTONE Chip Logo® are the property of Pantone, Inc.

Printed and bound in China
10 9 8 7

Abrams books are available at special discounts when purchased in quantity for premiums and promotions as well as fundraising or educational use. Special editions can also be created to specification. For details, contact specialsales@abramsbooks.com or the address below.

ABRAMS The Art of Books
195 Broadway, New York, NY 10007
abramsbooks.com

"I think it pisses God off if you walk by the color purple in a field somewhere and don't notice it."

—ALICE WALKER, *THE COLOR PURPLE*

Contents

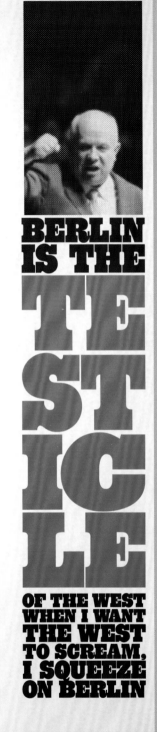

BERLIN IS THE TESTICLE OF THE WEST WHEN I WANT THE WEST TO SCREAM, I SQUEEZE ON BERLIN

NIKITA KHRUSHCHEV

Foreword
Seeing Red

FOR YEARS, JOSEF ALBERS TAUGHT A COLOR CLASS at Yale that began with an identical assignment. Participants were each asked to bring in examples of something red—found objects, loose remnants, the detritus of the everyday— their purpose or provenance of little concern. Thus challenged, students would enthusiastically disperse, each seeking the perfect specimen: from rescued textiles to tarnished metals, paper samples to paint chips, old discarded pizza boxes to treasured bits of propaganda, each hoped to impress the great master with dazzling brilliance and impeccable taste.

Returning to the studio to pin up their findings, the students soon saw that the intended lesson was little more than a demonstration of the impossible. Beauty is indeed in the eye of the beholder. Color is an exercise in visual slippage: it's intrinsically and deeply personal. No two reds could ever—indeed, would ever—match.

And that, observed Albers, was precisely the point.

Sean Adams is spot-on when he says that color is subjective. It's also tricky, idiosyncratic, and prone to mercurial shifts of temperament. Flowers bloom bright before fading. Pigments can be engineered to dye or to dissipate. Staring at a spot of blue for too long will result in a subsequent burst of perceived orange—a useful operation when explaining optics to students, but an exasperating exercise for anyone hoping to be rewarded for their scrutiny, or, for that matter, their stamina. It's all fascinating—if bewildering—making decisions at once perplexing and onerous.

This book provides an invaluable resource for visual practitioners, offering both conceptual guidelines and concrete examples for the color-challenged. Color perception is not only personal, it's contextual, gesturing to all sorts of invisible phenomena that orbit, for most of us, in a seemingly endless and unbidden referential haze. Colors spark memories, cue emotions, and trigger willful associations. When too close in value, adjacent colors can shift from harmonious to hilarious (certain bridal parties come to mind), while improperly contrasting hues will sooner compete than cooperate.

In the end, all color embraces a spectrum of light that may never be possible to fully comprehend. Aristotle tried, and so did Goethe and Wittgenstein. (Isaac Newton tried, too.) Perhaps this is why Josef Albers always returned to that deliciously simple exercise. My red is not now, nor will it ever be, the same as yours. And that, as this book so eloquently demonstrates, is precisely the point.

—JESSICA HELFAND

Introduction

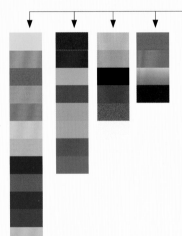

COLOR IS SUBJECTIVE AND EMOTIONAL. It is often the most volatile element of a project. To declare that the choice of a favorite color is inferior is to personally attack a person's core. A client may arbitrarily demand a specific color or reject another based on outwardly irrelevant reasons. Our response to a color is based on our life experiences and cultural associations. If locked in a green closet for most of childhood, a person may be green averse. Regardless of the numerous rational reasons presented, and backup of research, that individual will forever despise green.

This book does not exist as a technical manual on the light waves of primary, secondary, and tertiary colors. It is not a technical manual on the mixing of paint. There is a multitude of other sources that do that. *The Designer's Dictionary of Color* is a guide to the cultural, historical, and social meanings of a color. It is a resource with examples of successful application of each color and the range of options for an accompanying palette.

Chapters are divided into **warm, cool, neutral, and specialty colors**. Within each chapter, individual colors are presented with information including how designers have used the color, cultural issues and connections, and alternative nomenclature. Of course, color is not as simple as a crayon box, each color distinct and clear from each other. Coral may intersect with pink; avocado and olive share attributes. However, I have delineated each one while presenting the range of the color.

A traditional approach to color is to start with primary colors, then expand into secondary, and finally tertiary. These are included here. However, rather than following this convention, I have organized the colors into warm, cool, neutral, and specialty colors. This separation is connected more to the designer's creative process than the academic exercise of painting a color wheel.

Each color also includes a list of *successful applications*. These are listed to guide further research on that color and specific application listed.

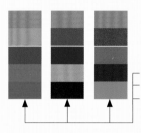

When working with color, most designers begin with a specific choice, perhaps a warm color such as orange; she then builds a palette around this color, pulling from other warm, cool, or neutral colors. The palette may be **monochromatic**, pulling from the shades, tints, and tones of the same color. It **may be polychromatic, using warm, cool, and neutral colors**. And finally, it may **be purposely dissonant to create surprise**.

Each color is presented with a range of palettes. Not to provide a tool to copy, but as a way to inspire the designer to play with color confidently and with power. This book follows the principle that there is no "wrong" color combination. Every color enjoys the company of every other color. The gods of good taste will not strike you dead if you combine brown and fuchsia. But you may add a new dynamic to a project.

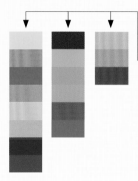

Expanding beyond the default swatch palette may be the difference between dull and powerful. Therefore, the reader will also find colors here that are **less expected, such as butter, mint, and fuchsia**. It is these colors, which live "in-between," that create interest. If the viewer needs to work to decide if turquoise is blue or green, he has invested time and energy and the project has greater mnemonic value.

Design is 90% persuasion: not to push a client to do something simply because it is cool, but because it is right. Every designer needs the tools to make an informed decision, and critically explain the choices. To describe the logic for using a bright yellow background with terms such as "bright" or "nice" is the first step to rejection and disagreement. To explain that this background color communicates optimism and warmth based on associations from 10,000 years of human culture will lead to approval.

Years ago, a client asked me for a specific color of green, Jaguar Green. After exhaustive research on the paint colors of Jaguar automobiles from 1922 to the present, I could not pinpoint the exact color he insisted existed. This green **was a color that lived only in his imagination, based on the memory of a green** Jaguar on a sunny afternoon in his youth. Only after I articulated the logical, cultural, and aesthetic reasons for the green I chose was he convinced that the final green was, indeed, Jaguar Green.

Glossary

CMYK:

Most four-color offset lithography and digital printing is based on a combination of CMYK: cyan, magenta, yellow, and black. The visible color is a combination of all or some of these combined as tiny halftone dots.

Usage:
"Make sure the files are linking to CMYK images when the project is sent to the printer."

Hue:

The hue is the property of the color that we identify, as in "red, green, yellow, etc." The hue is based on the visible wavelengths of light.

Usage:
"I need a hue closer to purple rather than red."

PMS:

PMS is an abbreviation for color created with the Pantone Matching System. This is a standardized color reproduction system that ensures the correct color is printed every time.

Usage:
"The company's logo uses a specific PMS color that can be printed anywhere in the world and will always match."

Primary Colors:

Red, yellow, and blue are the three primary colors. These are colors that can be mixed together to produce other "secondary" colors, but cannot themselves be produced from mixtures.

Usage:
"I can make any color with a combination of primary colors."

Purity:

The purity of a color is based on the intensity of color and whether any other color has been mixed with it.

Usage:
"A pure yellow is almost fluorescent. It will lose purity if I add magenta."

RGB:

Screen-based media uses RGB as the color system. The monitor displays an image, typography, and shape with a combination of RGB: red, green, and blue.

Usage:
"That intense fluorescent light blue color on the screen is an RGB color that cannot be replicated in print."

Saturation:

The saturation of a color is based on the degree of purity, from the pure color at 100% to gray at 0%. A highly saturated image is vibrant and bright. A desaturated image will appear dull, or sepia.

Usage:
"Please make sure the images are highly saturated. I want them to appear to be in Technicolor."

Secondary Colors:

Orange, green, and purple are created by mixing the three primary colors and are classified as secondary colors.

Usage:
"Please combine the yellow and red to make orange."

Shade or Tone:

The tone of a color is based on the amount of gray added. A tone can be more pure or subtle based on the amount of gray added.

Usage:
"The tone feels too strong, I'd like a quieter version."

Tertiary Colors:

Mixing a primary and a secondary color, such as red and purple, or two secondary colors, such as orange and green, produces tertiary colors.

Usage:
"When I mixed bright red and green, I created a tertiary color, brown."

Tint:

Adding white to a color creates a tint. As opposed to the tone, which creates a less vibrant color, the tint creates a more pastel or lighter version.

Usage:
"I prefer a tint of red to create light pink, rather than full force fire-engine red."

Value or Lightness:

Value is determined by the amount of illumination on a color. A color at 100% value will appear pure. At 50% value, the color will be darker.

Usage:
"I reduced the value to 75%, making it darker. This allows the white type to be legible on the color."

Warm Colors

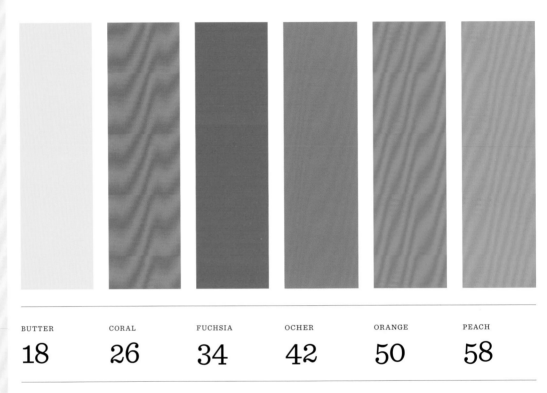

BUTTER	CORAL	FUCHSIA	OCHER	ORANGE	PEACH
18	26	34	42	50	58

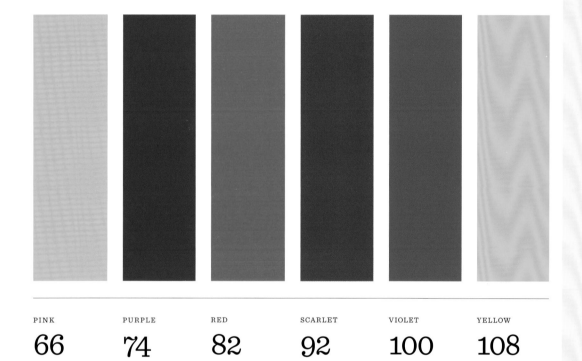

PINK	PURPLE	RED	SCARLET	VIOLET	YELLOW
66	74	82	92	100	108

BUTTER

「ファッション」「ジュエリー」「プロダクト」
様々な呼び方がありますが、
私たちのつくるものは 簡単に一つの言葉では表せなかったり、
分類するのが難しいことがあります。

ただ共通するのは
「日常の中のあらゆるシーンで身につけたり触れたりするもの」
ということです。

日常の中に在るもの。
"BUTTER"

焼きたてのトーストにのせた固まったバターは、
時間が経つとすっと 溶けだし
しみ込み トーストの一部となります。
想いのままに切り取ったバターを持ち帰り、
それぞれの日常に
すっと 馴染ませてもらえると嬉しいです。

□ FASHION
□ JEWELRY
□ PRODUCT

□□ Antamina
□ B
□□ KiKKOU
□ mamoru fukui
□ proef
□ pssst,아ir

GROUP EXHIBITION

BUTTER 01

FASHION JEWELRY PRODUCT

2014
OCT — OCT
25 — 27
SAT MON
1:00PM - 7:00PM

AT SPinniNG MiLL OSAKA SAKAI

GROUP EXHIBITION
BUTTER 01
FASHION JEWELRY PRODUCT

BRANDS

Antamina B KiKKOU proef pssst,아ir

6組のクリエイターによる 初の展示販売会 "BUTTER"

会期：2014年10月25日（土）〜27日（月）　時間：13〜19時　会場：SPinniNG MiLL

Butter

Butter \ˈbə-tər

From Old English *butere*, of West Germanic origin; related to Dutch *boter* and German *Butter*, based on Latin *butyrum*

Butter yellow is a pale yellow created by adding white to a pure primary yellow. Butter was a popular color in the 1950s due to its cheerful nature. It doesn't have the intensity of primary yellow and is considered more pleasant and gentle. Some designers use butter as a neutral, as it recedes next to most other colors.

Butter has the benefit of adding a sense of happiness without the danger of being garish or obtrusive. Conversely, it can be seen as anemic or weak. Due to its more neutral nature, it invokes less extreme emotions with the viewer. This also helps to minimize any strong cultural connections.

CULTURAL MEANINGS

Butter shares some cultural meanings with primary yellow. It represents sunshine, optimism, and happiness in most cultures. It is associated with a happy domestic experience, with a creamy and soft character. It is also seen as institutional, as it is used in many schools, hospitals, and government offices.

SUCCESSFUL APPLICATIONS
Post-it notes
Dr. Spencer Silver, Art Fry, 3M, 1974

Steel kitchen cabinets
Youngstown Metal, c. 1950

Golden Guernsey Butter packaging
Unknown, 1948

OTHER NAMES
Light Yellow
Cream
Lemon
Daffodil
Vanilla

OPPOSITE
Butter Group Exhibition
asitanosikaku ~ 2014
Poster
True to the name of the exhibition, the butter yellow combines with the "packaging" typography to communicate the idea of butter.

ABOVE
Larkspur
William Morris ~ 1874
Wallpaper
Morris was a founder of the arts and crafts movement. He designed this handmade wallpaper to incorporate the natural world into the interior of a house as a reaction to the Industrial Revolution.

OPPOSITE
ReadyMade
Volume, Inc. ~ 2005
Magazine
The guide to DIY projects incorporates a soft butter tone referencing technical manuals and appliance directions.

CD WALL MURAL

c/02

RAW MATERIAL

Have you switched to the soft pack of CDs? **Are all your empty jewel cases starting to block the way to the kitchen? Time to make something from that mess of plastic brittle. Remember, jewel cases are fabricated from Thermoset, which can't be melted down and turned into two-liter Coke bottles. It's our way or the highway to the dump for these fellers. But look at all they have to offer: protection against the elements; translucency; clean, modern lines. For all those reasons and more, use your empties to make a wall mural. It's yet another step in your march against passive domesticity.**

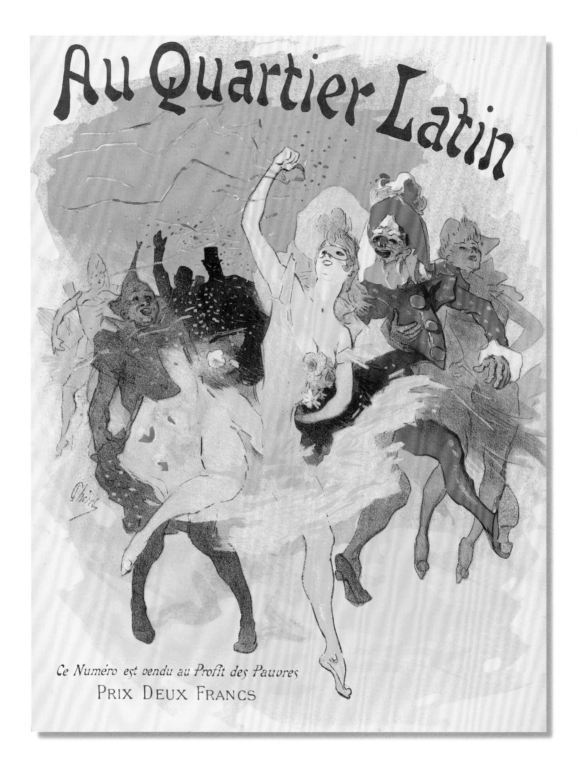

Au Quartier Latin
Jules Chéret ~ 1894
Poster

Chéret is considered the father of the modern poster. His work has a dynamic energy through the use of subtle color, lighting, and movement.

BMW Isetta
Ermenegildo Preti, Pierluigi Raggi ~ 1955
Car

The Isetta was originally designed by the Italian firm Iso SpA in 1953. BMW began production of the car in 1955. It was the world's first mass-production car to achieve fuel consumption of 78 mpg (3 L/100 km).

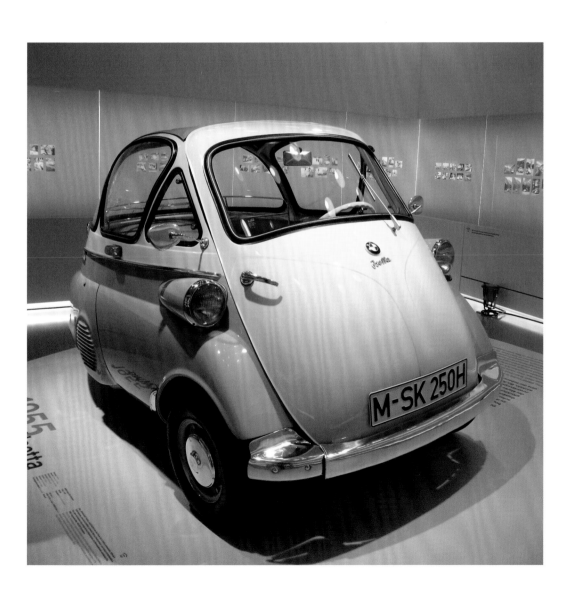

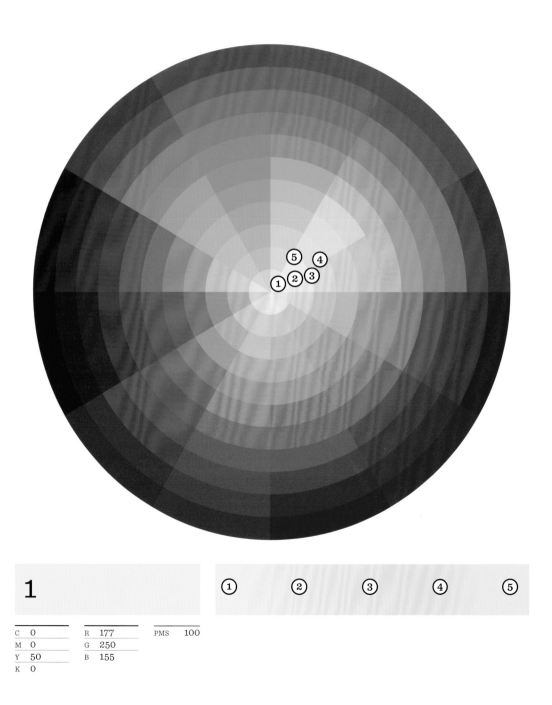

1		

C	0	R	177	PMS	100
M	0	G	250		
Y	50	B	155		
K	0				

Palette Variations

1

C	0		C	0		C	0		C	20		C	40
M	0		M	10		M	25		M	40		M	50
Y	50		Y	100		Y	100		Y	80		Y	100
K	0		K	0		K	0		K	0		K	0

2

C	5		C	0		C	0		C	0		C	50
M	0		M	50		M	100		M	0		M	0
Y	50		Y	100		Y	70		Y	100		Y	100
K	0		K	0		K	0		K	0		K	0

3

C	0		C	0		C	0		C	0		C	0
M	10		M	0		M	0		M	0		M	0
Y	50		Y	0		Y	0		Y	0		Y	0
K	0		K	25		K	50		K	75		K	100

4

C	0		C	0		C	10		C	60		C	25
M	10		M	20		M	0		M	0		M	0
Y	60		Y	50		Y	50		Y	40		Y	0
K	0		K	0		K	0		K	0		K	0

5

C	0		C	0		C	0		C	30		C	0
M	0		M	0		M	60		M	100		M	0
Y	70		Y	100		Y	100		Y	0		Y	0
K	0		K	50		K	45		K	0		K	50

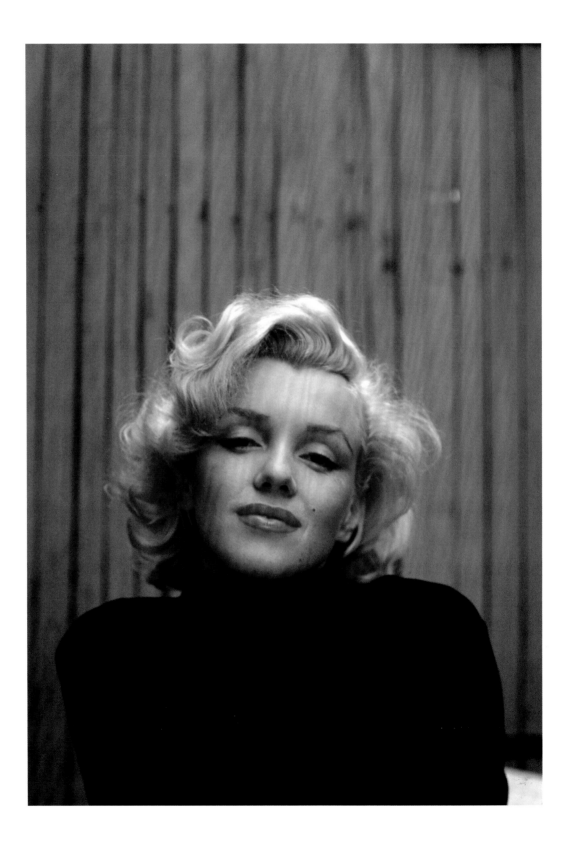

Coral

Coral \ˈkȯr-əl
From Middle English via Old
French from Latin *corallum*, **from**
Greek *korallion, kouralion*

Coral is neither pink nor peach. It is a color that exists between these. It is associated with femininity, gentleness, romance, and the tropics. These connections work to communicate the tone of an idea swiftly. A coral poster will immediately be read as positive and friendly. Coral has more sensuality than pure pink, which can feel juvenile. As the color of the interior of certain shells, and used as a prominent paint color throughout the Caribbean, coral has associations with a carefree and gentle holiday.

CULTURAL MEANINGS

Coral roses are a symbol of desire. In Buddhism, it symbolizes the energy of the life force. In China, it is a symbol of longevity. Coral is a sensitive color. If it shifts toward yellow, it will become peach, or a sickly flesh tone. A shift toward the red creates pink. Coral is also known as salmon, a term that was used in automobile color options.

SUCCESSFUL APPLICATIONS
Thunderbird Samoan Coral
Ford, 1964

Nantucket Reds pants
Philip C. Murray, 1960s

The Royal Hawaiian Hotel
Warren & Wetmore, 1927

OTHER NAMES
Salmon
Watermelon
Grapefruit
Shell Pink
Bright Rose

OPPOSITE
Marilyn Monroe
Alfred Eisenstaedt - 1953
Photograph
Marilyn Monroe was a contradiction of sensual and innocent, dangerous and virginal. Here, this is created with the combination of black representing danger with the innocent coral lipstick and blonde hair.

ABOVE
Dynamic
Paul Hoppe – 2013
Typeface
The Dynamic typeface responds to user interaction. Its pink environment creates a sense of welcome and warmth.

OPPOSITE
Rito
Haim Amar – 2014
Poster
In this poster for a museum focused on religion in Latin America, Amar explores the relationship between Catholicism and Santeria.

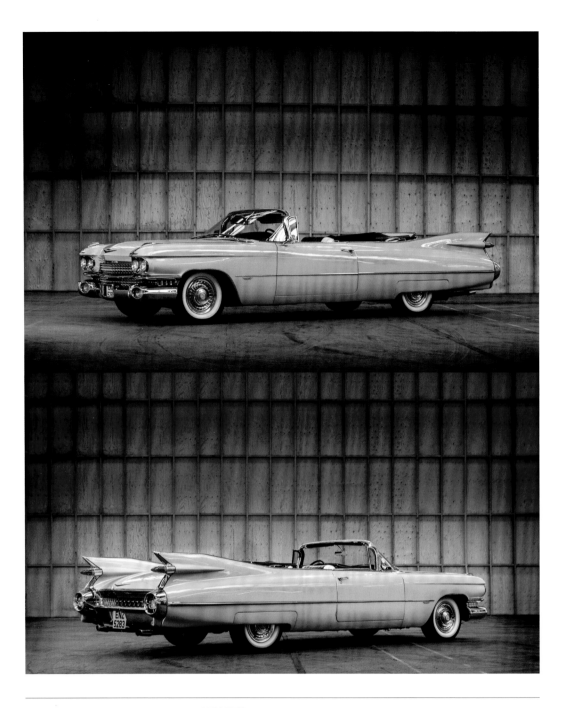

ABOVE
Cadillac
General Motors · 1959
Car
As a response to the drab years of World War II, colors such as coral and mint were popular postwar. The exuberance is reflected in a coral Cadillac.

OPPOSITE
Burning Settlers Cabin
Sean Adams · 2015
Poster
In contrast to the fiery destruction of the image, the solid coral color softens the message and adds levity.

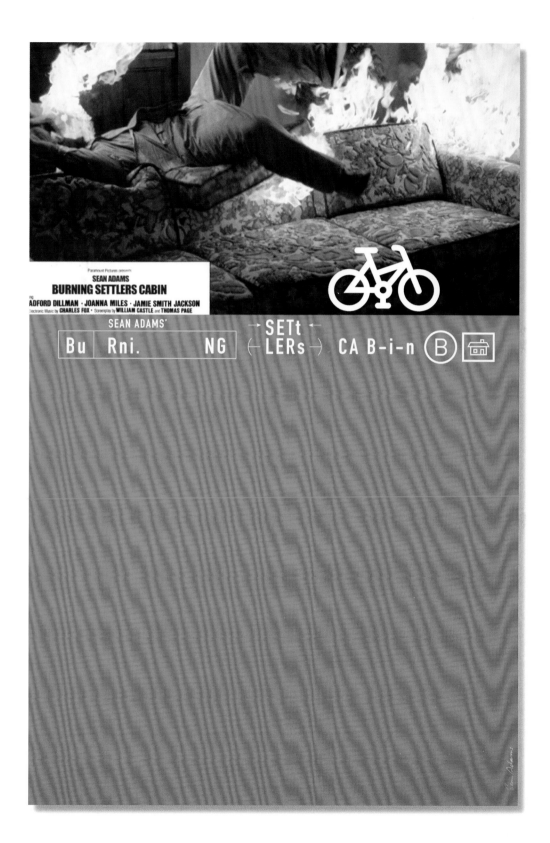

Paramount Pictures presents
SEAN ADAMS
BURNING SETTLERS CABIN
ng
ADFORD DILLMAN · JOANNA MILES · JAMIE SMITH JACKSON
Electronic Music by **CHARLES FOX** · Screenplay by **WILLIAM CASTLE** and **THOMAS PAGE**

SEAN ADAMS'
Bu Rni. NG SETt LERs CA B-i-n B

1					
C	0	R	255	PMS	178
M	80	G	90		
Y	60	B	90		
K	0				

Palette Variations

1

C	0	C	0	C	0	C	0	C	0
M	80	M	100	M	50	M	25	M	85
Y	60	Y	100	Y	100	Y	100	Y	0
K	0	K	0	K	0	K	0	K	0

2

C	0	C	0	C	0	C	60	C	0
M	60	M	10	M	100	M	0	M	0
Y	50	Y	100	Y	0	Y	40	Y	100
K	0	K	0	K	0	K	0	K	50

3

C	0	C	0	C	40	C	20	C	10
M	70	M	0	M	60	M	20	M	10
Y	30	Y	0	Y	100	Y	20	Y	20
K	0	K	75	K	30	K	0	K	0

4

C	0	C	20	C	5	C	0	C	20
M	40	M	5	M	0	M	0	M	0
Y	20	Y	0	Y	50	Y	70	Y	20
K	0	K	0	K	0	K	0	K	0

5

C	0	C	10	C	0	C	0	C	0
M	50	M	10	M	0	M	0	M	0
Y	50	Y	20	Y	0	Y	0	Y	0
K	0	K	0	K	50	K	75	K	100

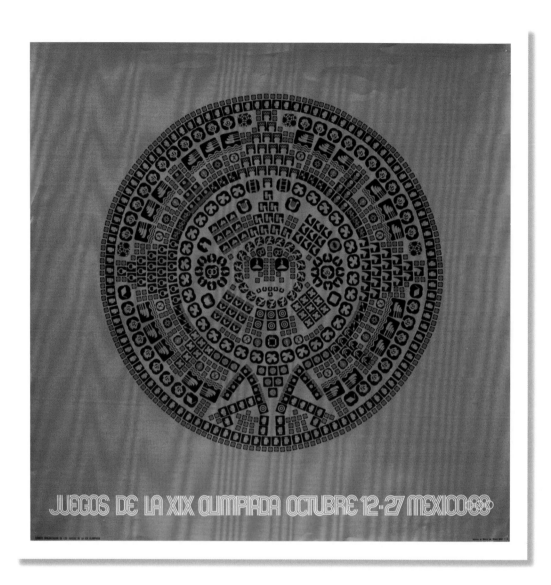

Fuchsia

Fuchsia \ˈfyü-shə
From modern Latin, named in honor
of Leonhart Fuchs, 1501–1566,
a German botanist

Fuchsia communicates intense energy, nonconformity, and new ideas. It is vibrant and pure. Fuchsia is an unexpected color and attracts attention. This makes it effective, but also risky. Due to its intensity, a viewer's emotional connection is increased. As a positive, it will stand out in the marketplace or environment. On the negative side, it may feel garish and annoying.

In printing, fuchsia is not 100% magenta. The designer should use a specific Pantone color such as Rhodamine Red. If using only process color, adding 10–20% yellow will decrease the process magenta color.

CULTURAL MEANINGS
Fuchsia, which is extremely close to magenta, is a symbol of the heart chakra in Eastern religions. It represents spring and renewal in Western society based on its origin, the fuchsia flower. Fuchsia does not communicate femininity as pink does. The force of its saturation reads as rebellious.

SUCCESSFUL APPLICATIONS
T-Mobile logo
Interbrand, 1999

Tab soda packaging
Coca-Cola, 1963

Pink's hair (the singer)
1999

OTHER NAMES
Magenta
Rhodamine Red
Flame
Hot Pink
Bright Pink

OPPOSITE
Mexico City Olympics
Lance Wyman ~ 1968
Poster
Wyman used a color palette based on Mexican and Latin American cultures for the Mexico City Olympics. Symbols for each event create a Mayan sun against the intense fuchsia background.

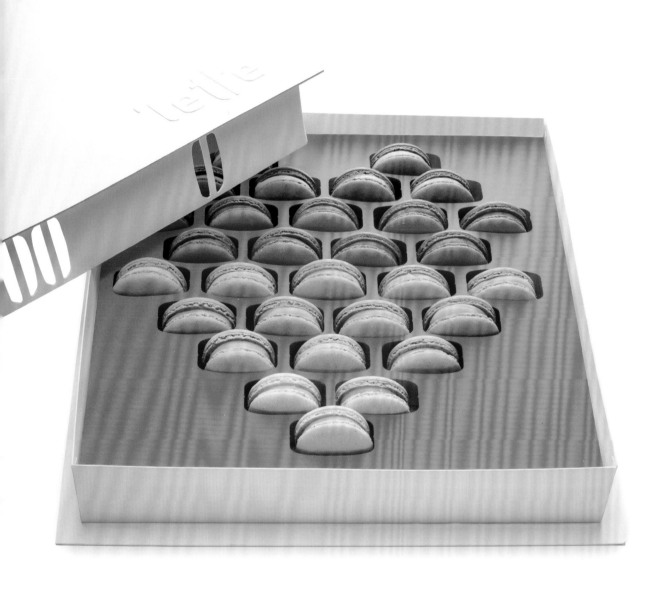

ABOVE
'Lette Macarons
ALM Project, Inc - 2015
Packaging
The goal is to highlight the soft colors of the
macaron. Fuchsia does this as a contrasting,
vibrant, and cheerful color.

OPPOSITE
Boomerang Identity
Primal Screen - 2015
Broadcast design
Fuchsia and yellow colors and isometric
backgrounds hide secret doors concealing
a host of surprises in this series of six IDs
created for the Boomerang Network.

PAGES § 38–39
"Make Sense"
Supply - 2014
B&F Papers advertisement
Supply crafted this promotion for B&F Papers
by embracing the classical influence of the
Rives paper range and adding a touch of rebel-
lion with fuchsia backgrounds and images.

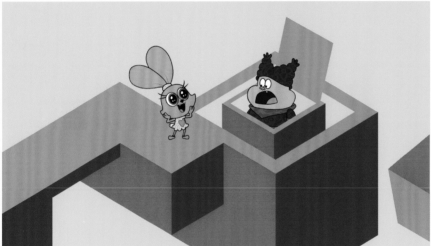

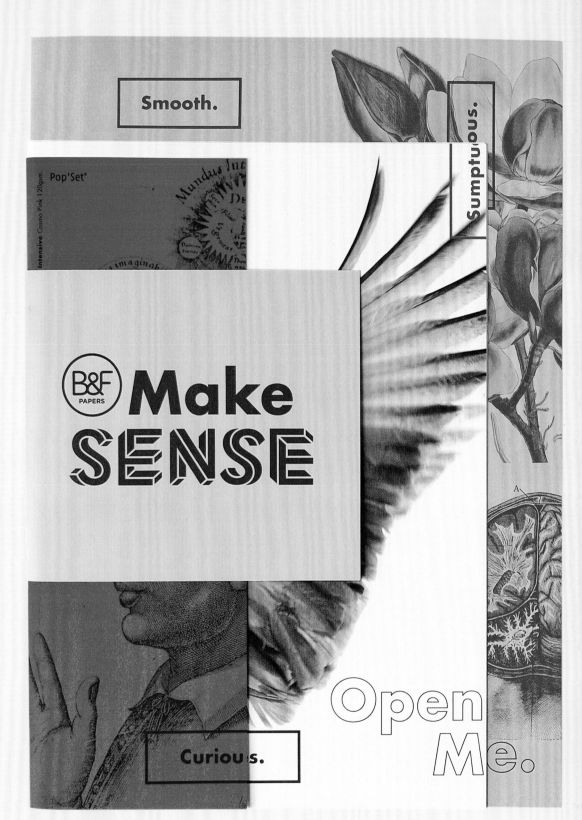

Riv

sur

geo

wh

me

car

wa

Ser

wh

exc

Arj

certified to be sustaina

Arjowiggins mills are

(international environm

standard).

We have five branches around the country that can help you find the best paper selections. For over 80 years we've been providing Kiwi designers, printers and clients with expert knowledge, quality paper stocks and helpful service like no other. We're New Zealand's smart paper company.

WWW.BFPAPERS.CO.NZ

Color Range

1					
C	0	R	235	PMS	
M	100	G	0	PROCESS	
Y	0	B	145	MAGENTA	
K	0				

Palette Variations

1

C 0	C 30	C 0	C 0	C 0
M 100	M 100	M 60	M 50	M 100
Y 0	Y 0	Y 50	Y 10	Y 100
K 0	K 0	K 0	K 0	K 0

2

C 10	C 0	C 0	C 50	C 70
M 100	M 10	M 100	M 0	M 0
Y 0	Y 100	Y 100	Y 100	Y 0
K 0	K 0	K 0	K 0	K 0

3

C 15	C 0	C 0	C 0	C 0
M 85	M 0	M 0	M 0	M 0
Y 0	Y 0	Y 0	Y 0	Y 0
K 0	K 75	K 25	K 5	K 100

4

C 0	C 5	C 40	C 25	C 0
M 85	M 0	M 0	M 0	M 40
Y 0	Y 50	Y 30	Y 100	Y 20
K 0	K 0	K 0	K 0	K 0

5

C 0	C 90	C 100	C 100	C 0
M 100	M 100	M 20	M 70	M 100
Y 30	Y 15	Y 100	Y 0	Y 100
K 0	K 0	K 0	K 0	K 20

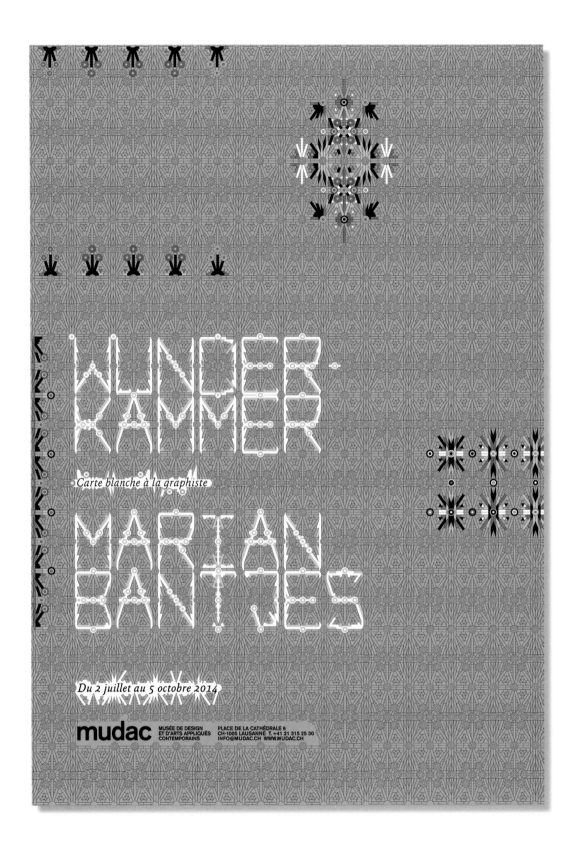

Ocher

Ocher \ˈō-kər\
From Middle English Old French *ocre*,
via Latin from Greek *ōkhra* "yellow
ocher" *oh-kr*; from Greek: *okhrós*,
(pale yellow, pale)

Yellow ocher is a natural earth pigment that consists mostly of clay colored by iron oxides. Ocher can range from tan to slightly green. Ocher is not yellow, mustard, or brown. It is an interesting combination of all three. The complexity of the color asks the viewer to understand it. This creates a proprietary and memorable experience.

Ocher was popular in the 1920s and then again in the 1970s. It has been referred to as sienna, harvest gold, and butterscotch. As a color tied to a specific period, it provokes strong opinions. It is a color that is beloved or deeply reviled.

CULTURAL MEANINGS
Ocher was used in Egyptian tombs to represent the sun god Ra. It has traditionally been connected with the natural world: the glow of the sun and dirt of the earth.

SUCCESSFUL APPLICATIONS
Braniff Airlines palette
Alexander Girard, 1965

Volkswagen Pampas Yellow
Volkswagen, 1970

The Bus
Honolulu Transit System, 1974

OTHER NAMES
Butterscotch
Harvest Gold
Sienna
Mustard
Old Gold

OPPOSITE
Wunder Kammer
Marian Bantjes - 2014
Poster
Bantjes' poster for an exhibition of her work incorporates a Navajo color palette of ocher, turquoise, scarlet, and black. All elements incorporate seamlessly with the repeat pattern.

Megaloceros at Lascaux
Unknown ~ 15,000 BCE
Cave painting
Iron oxide was used to create the ocher
tones in the caves at Lascaux. This image is
a Megaloceros, an extinct large deer.

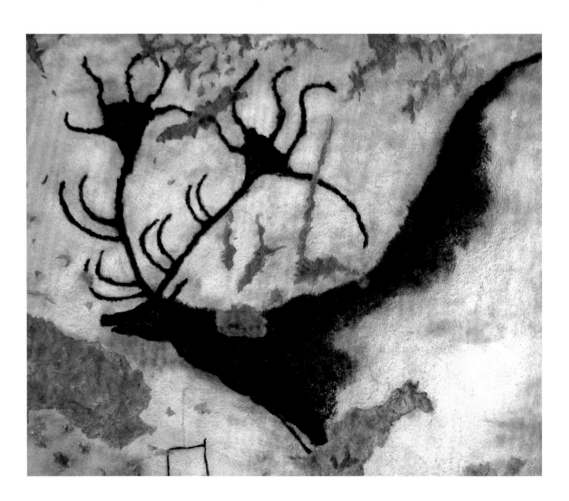

LAX Airport
Charles Kratka - 1961
Mural
Here, a section of tile mosaics are designed
to make 300-foot-long tunnels leading to
baggage claim seem shorter. The geometric
panels in seven tunnels represent the
changing seasons.

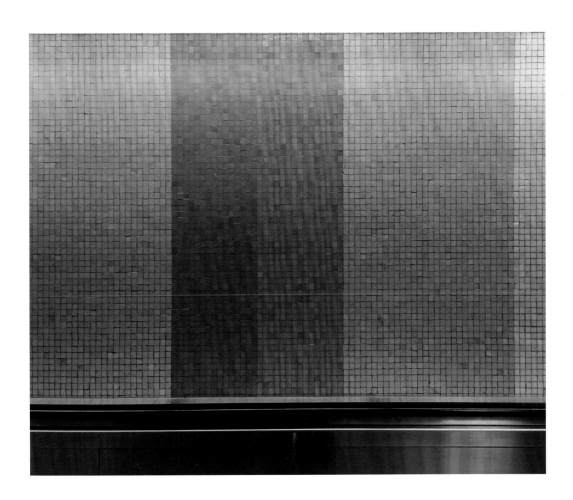

Colle+McVoy's packaging for CROPLAN (WinField's seed brand) uses shades of ocher as part of a palette to represent the organic product and its superior genetics and technology .

Bitters incorporates sculpted ceramic forms with rich color into architecture, adding a humane quality, often missing, to cold and modern industrial architecture focused on function.

46

THE DESIGNER'S DICTIONARY OF COLOR

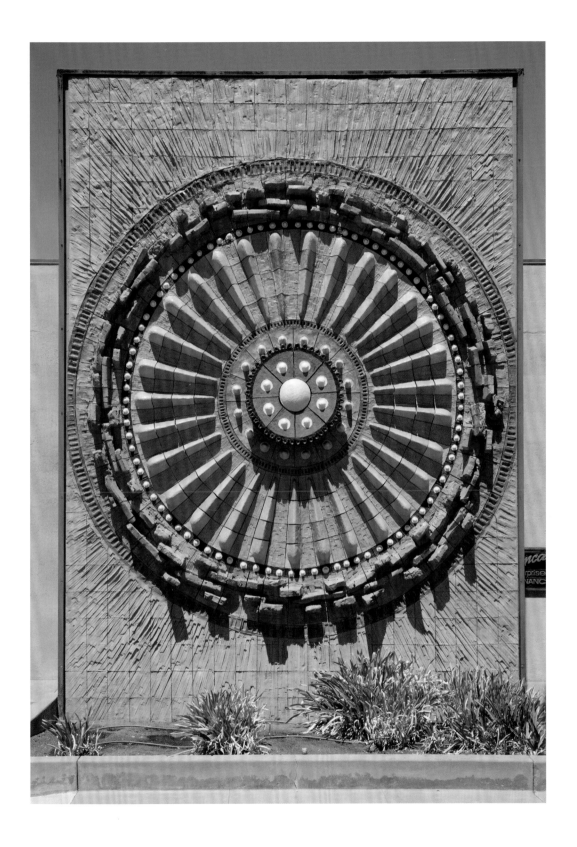

Color Range

1

C	20	R	205	PMS	117
M	45	G	150		
Y	100	B	0		
K	0				

Palette Variations

1

C	20		C	10		C	0		C	0
M	45		M	0		M	10		M	25
Y	100		Y	80		Y	100		Y	100
K	0		K	0		K	0		K	0

2

C	15		C	0		C	0		C	0		C	50
M	30		M	70		M	100		M	10		M	0
Y	100		Y	100		Y	0		Y	100		Y	100
K	0		K	0		K	0		K	0		K	0

3

C	20		C	0		C	0		C	0		C	0
M	40		M	0		M	0		M	0		M	0
Y	100		Y	0		Y	0		Y	0		Y	0
K	0		K	25		K	50		K	75		K	100

4

C	20		C	10		C	0		C	25
M	40		M	0		M	50		M	0
Y	80		Y	50		Y	20		Y	0
K	0		K	0		K	0		K	0

5

C	40		C	0		C	25
M	50		M	0		M	80
Y	100		Y	100		Y	100
K	0		K	50		K	15

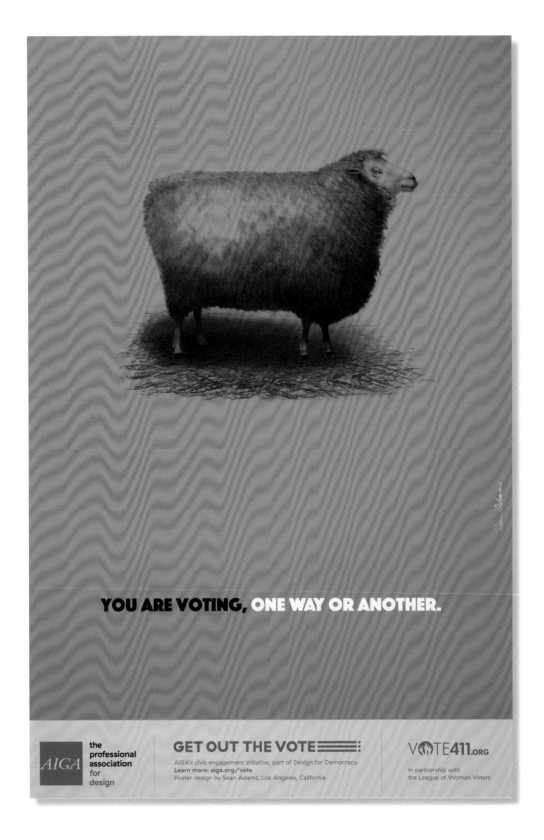

Orange

Orange \\'är-inj
From late Middle English, Old French
orenge (in the phrase *pomme d'orenge*),
based on Arabic *nāranj,* from Persian
nārang

Orange is one of the colors that are especially subjective. Orange is a combination of red and yellow. Living between these primary colors, one person may insist it is red; another may call it yellow. Orange has the positive attributes of heat, energy, youth, and happiness. It is related to summer sunsets and the color of flames in a fireplace.

Orange is used to create a sense of immediacy and spontaneity. Fast-food restaurants use orange in the interior to energize the customer and hasten their departure. Orange may be negatively seen as loud or annoying.

CULTURAL MEANINGS
In Eastern philosophy, orange represents the creative center as the second chakra, located below the navel. In Northern Ireland, orange represents Protestantism. In the United States and Canada, orange, combined with black, represents Halloween.

SUCCESSFUL APPLICATIONS
Nickelodeon brand
AdamsMorioka, 2001

Hermès boxes
Robert Dumas, Jean-René Guerrand, 1947

Harley Davidson Eaglethon poster
VSA Partners, 1992

OTHER NAMES
Carrot
Cheddar
Marigold
Tangerine
Warm Red

OPPOSITE
Get Out The Vote
Sean Adams ~ 2016
Poster
The poster provides the message that an individual is voting, whether actively or by doing nothing. Rather than using colors connected to partisan politics, red or blue, Adams uses a neutral orange.

BELOW

L'Argent
Henri de Toulouse-Lautrec ~ 1895
Theater program

Inspired by the flat forms and simple colors
of Japanese woodblock prints, Toulouse-
Lautrec simplifies the forms to three solid
blocks of color: orange, peach, and black.

OPPOSITE

Repeat Patterns
Andrea Tinnes ~ 2004
Typeface

Repeat is a pattern-based typeface in two
different versions. These can be combined
or superimposed. The patterns use simple
geometric shapes and complex organic
illustrations, here in vibrant warm tones.

52

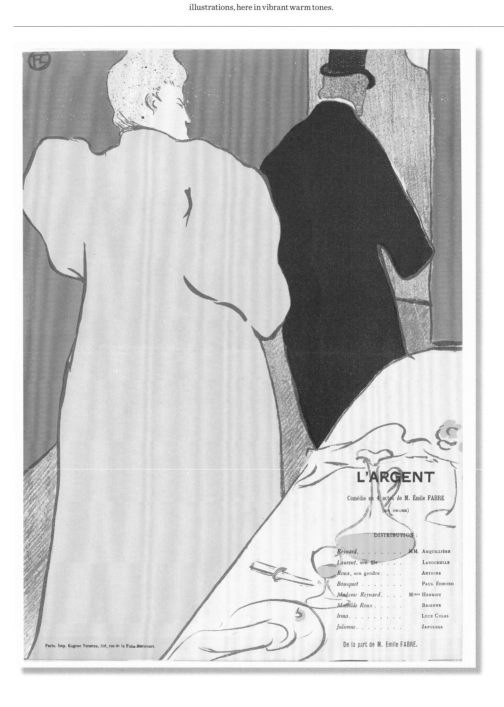

Womb Chair
Knoll, Inc., Eero Saarinen - 1947
Chair
Eero Saarinen designed the Womb Chair
at Florence Knoll's request for "a chair that
was like a basket full of pillows, something
she could curl up in." The chair is made by
applying foam over a fiberglass shell.

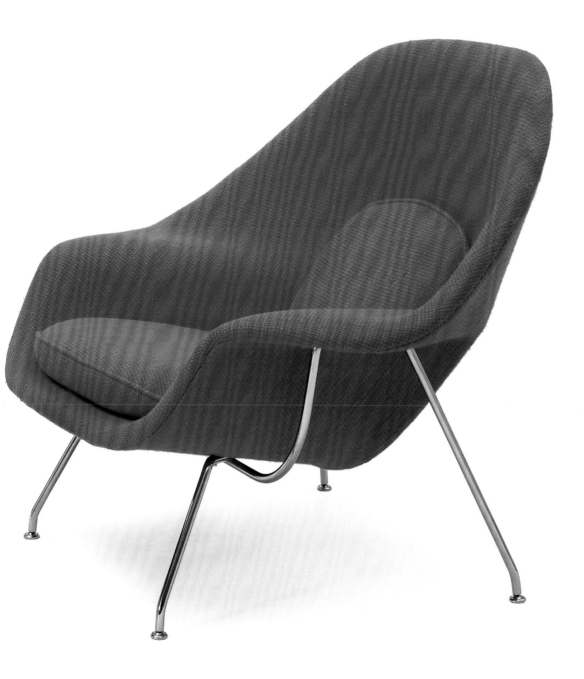

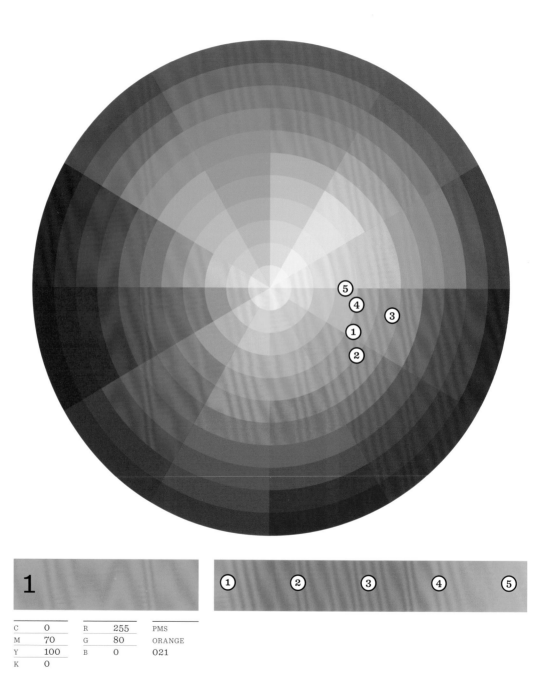

1				

C	0	R	255	PMS
M	70	G	80	ORANGE
Y	100	B	0	021
K	0			

Palette Variations

1

C	0	C	25	C	40	C	20
M	70	M	80	M	0	M	40
Y	100	Y	100	Y	100	Y	100
K	0	K	15	K	60	K	0

2

C	0	C	25	C	60	C	0	C	0
M	85	M	0	M	0	M	100	M	10
Y	100	Y	100	Y	40	Y	100	Y	100
K	0	K	25	K	0	K	0	K	0

3

C	10	C	0	C	40	C	25	C	10
M	80	M	0	M	25	M	15	M	0
Y	100	Y	100	Y	100	Y	60	Y	50
K	0	K	60	K	0	K	0	K	0

4

C	0	C	0	C	0
M	50	M	30	M	0
Y	100	Y	40	Y	70
K	0	K	0	K	0

5

C	0	C	0	C	0	C	0	C	0
M	30	M	0	M	0	M	0	M	0
Y	100	Y	0	Y	0	Y	0	Y	0
K	0	K	25	K	50	K	75	K	100

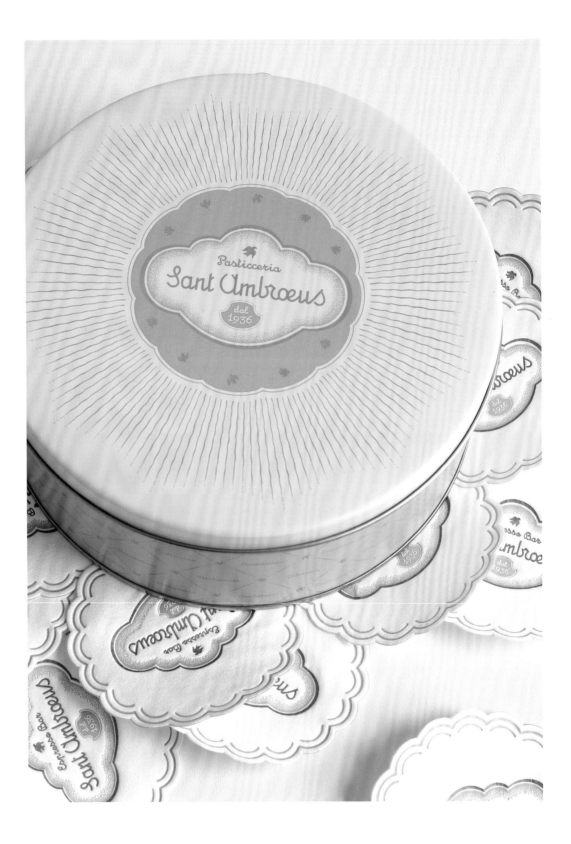

Peach

Peach \pēch
From late Middle English, from Old French *pesche*, from medieval Latin *persica*, from Latin *persicum (malum)*, literally "Persian apple"

Peach is a color that depends on good nomenclature. Calling it "flesh" will be less palatable than "peach." It is a lighter tone of orange. Unlike orange, with its associations of energy and heat, peach is soft, nurturing, warm, and sweet. Because of the connection to the fruit, the color invokes a fuzzy feeling and delicious taste. If the color has too much yellow, it will read as jaundice. If it has too much red, it is Barbie® flesh.

CULTURAL MEANINGS
The ancient Romans associated the color and the fruit with the goddess Venus. They considered the fruit to be an aphrodisiac. In Japan and China, peach represents the Mother Goddess and her life substance. The peach is a female goddess symbol in the same way that the phallus is a symbol of a masculine god.

SUCCESSFUL APPLICATIONS
Bridesmaid dresses
c. 1965–present

Valley of the Dolls book cover
Evan Gaffney, 1966

L'Argent poster
Henri de Toulouse-Lautrec, 1895

OTHER NAMES
Apricot
Blossom
Flesh
Melon
Shell

OPPOSITE
Sant Ambroeus
Mucca Design Corp. ~ 2014
Branding
Sant Ambroeus is one of Milan's most revered restaurants. For its location on Madison Avenue in Manhattan, Mucca reworked the original logotype and designed a pattern inspired by traditional Italian confectionery paper.

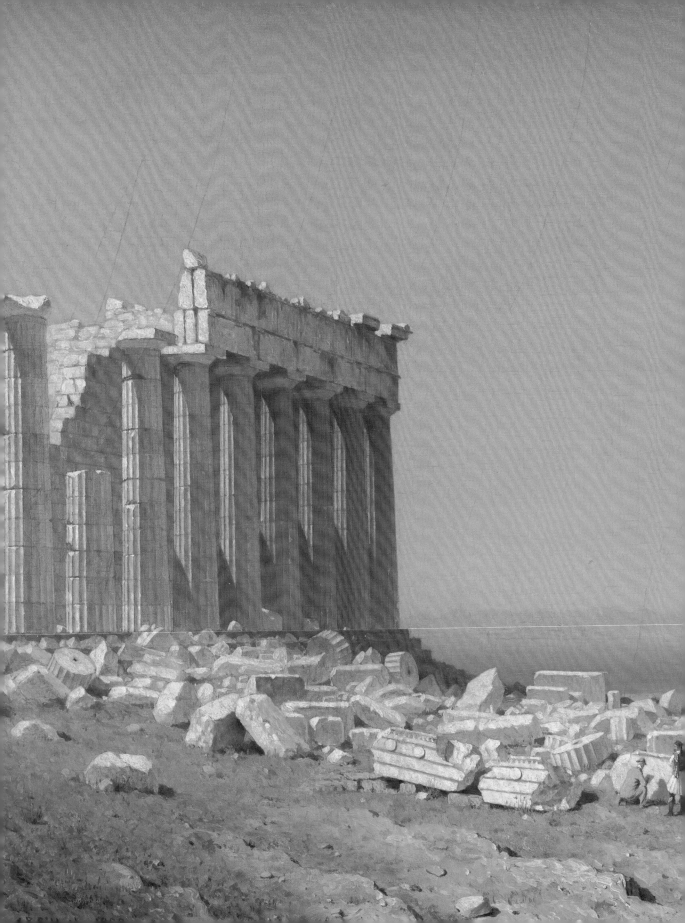

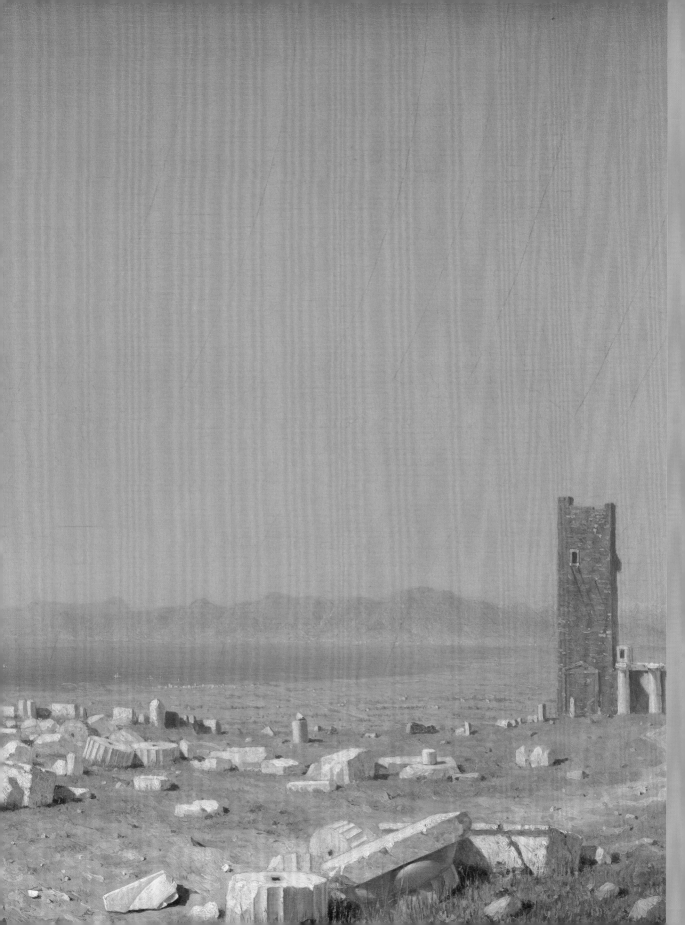

Ruins of the Parthenon
Sanford Robinson Gifford ~ 1880
Painting
Gifford's style, Luminism, was focused on detail and the effects of light. His subject matter—a Romantic landscape—is heavily reliant on subtle colors and soft pastel shades.

BELOW
The Beverly Hills Hotel, Hotel Bel-Air
Hernando Courtright, owner ~ 1948
Photograph
The exterior was painted its distinctive peachy pink to complement the sunset colors in Beverly Hills and the popular country club style of that time.

OPPOSITE
C.O.L.A.09
Louise Sandhaus Design ~ 2009
Journal cover
Inspired by the gradations of light in the Los Angeles sky, Sandhaus uses a photo of a sunset for the cover of a journal for the Los Angeles Department of Cultural Affairs.

62

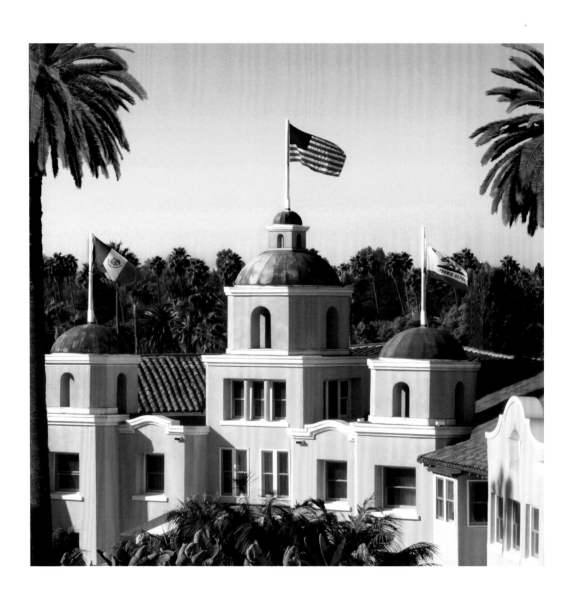

C.O.L.A.09

INDIVIDUAL
ARTIST
FELLOWSHIPS

DCa DEPARTMENT OF CULTURAL AFFAIRS
City of Los Angeles

Color Range

1

C	0	R	255	PMS	170
M	60	G	135		
Y	60	B	100		
K	0				

Palette Variations

1

C	0	C	20	C	0	C	0	C	25
M	60	M	40	M	10	M	25	M	80
Y	60	Y	80	Y	100	Y	100	Y	100
K	0	K	0	K	0	K	0	K	15

2

C	0	C	50	C	60	C	30	C	0
M	30	M	20	M	0	M	20	M	100
Y	40	Y	0	Y	40	Y	100	Y	0
K	0	K	0	K	0	K	0	K	0

3

C	0	C	0	C	40	C	15	C	15
M	40	M	0	M	40	M	30	M	15
Y	70	Y	20	Y	40	Y	30	Y	45
K	0	K	75	K	0	K	0	K	0

4

C	0	C	0	C	20	C	0	C	25
M	20	M	0	M	0	M	15	M	0
Y	50	Y	50	Y	20	Y	0	Y	0
K	0	K	0	K	0	K	0	K	0

5

C	0	C	20	C	40	C	15	C	10
M	50	M	20	M	40	M	15	M	10
Y	50	Y	20	Y	40	Y	45	Y	20
K	0	K	0	K	0	K	0	K	0

THE DESIGNER'S DICTIONARY OF COLOR

The William Shields Foundation 2017

Unheard Voices 09.23.16–02.17.17

Pink

Pink \\piŋk
From the mid-17th century, from the plant pink (*D. plumarius*), the early use of the adjective being to describe the color of the plant's flowers

Pink has definite feminine connotations. It communicates romance, compassion, innocence, and fragility. Pink is used for baby girls' rooms and clothing. It has gender connotations that have been questioned for the last fifty years. It is, therefore, a politically charged color. The Nazis used a pink triangle to identify homosexuals. The Feminist Movement rejected pink as an identifier of sweetness and domesticity.

Pink also communicates warm sunsets, pink sand beaches, and house colors in tropical climates. It is a useful tool to create a calming effect or defuse a potentially volatile subject.

CULTURAL MEANINGS
Medieval Christians identified the five petals of the pink rose with the five wounds of Christ, and pink roses were later associated with the Virgin Mary. Modern Western cultures commonly associate pink with Valentine's Day and Easter. Pink is also used as a term for female sexual organs, as in *Surrender the Pink* by Carrie Fisher.

SUCCESSFUL APPLICATIONS
Mary Kay Pink Cadillac
Mary Kay Ash, c.1960

Plastic pink flamingos
Don Featherstone, 1957

My Fair Lady poster
Bob Peak, 1964

OTHER NAMES
Baby Pink
Bubblegum
Champagne
Geranium Pink
Rose

OPPOSITE
Unheard Voices
Sean Adams - 2016
Poster
Designed for an exhibition of photographs of LGBT authors, this poster uses a large negative space of pink. This references the subject matter and contrasts with the black and white photography.

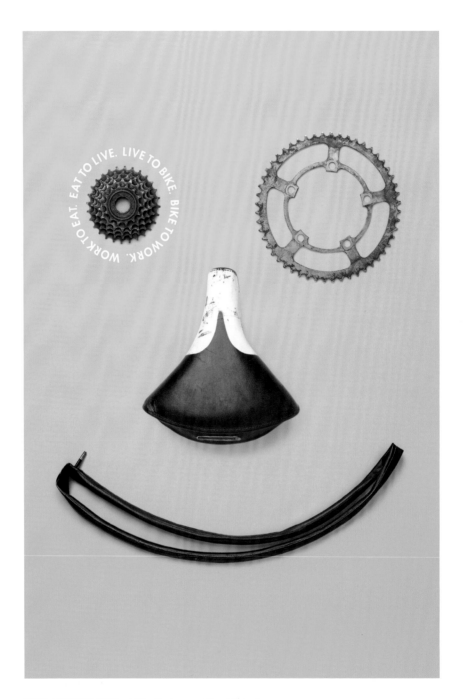

EAT TO LIVE. LIVE TO BIKE. BIKE TO WORK. WORK TO EAT.

Public Bikes
VSA Partners, Inc., Dana Arnett ~ 2015
Poster

Arnett's poster communicates that the under-
lying *raison d'être* for riding a bike is to put a
smile on our faces, and perhaps also that even
a flat tire can bring joy if repurposed correctly.

Florida
Paula Scher ~ 2014
Painting

Scher describes her intricate paintings
as "abstract expressionist information.
It's really more a spirit of the information."
The pink and turquoise become tropical
gestures against a deep black ocean.

OPPOSITE
Barbie
Ogilvy & Mather / BIG · 2014
Retail store
The corporate color of Barbie, pink, is used
liberally to reinforce the brand message
and create unity with the multiple styles of
clothing and dolls.

BELOW
Bottega Louie
Erica Gibson and Danny Bobbe · 2015
Packaging
The packaging for one of Los Angeles's
most popular restaurants, Bottega Louie, is
designed to evoke a feeling of exclusivity and
grandeur. The light pink bags, not bubblegum
pink, reference fine European dining.

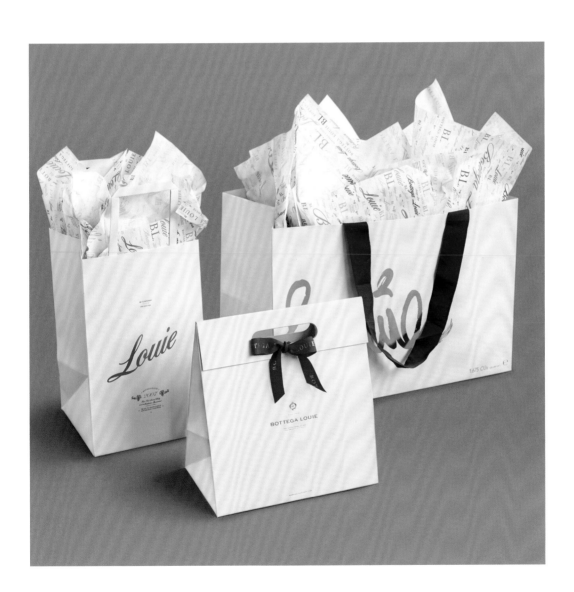

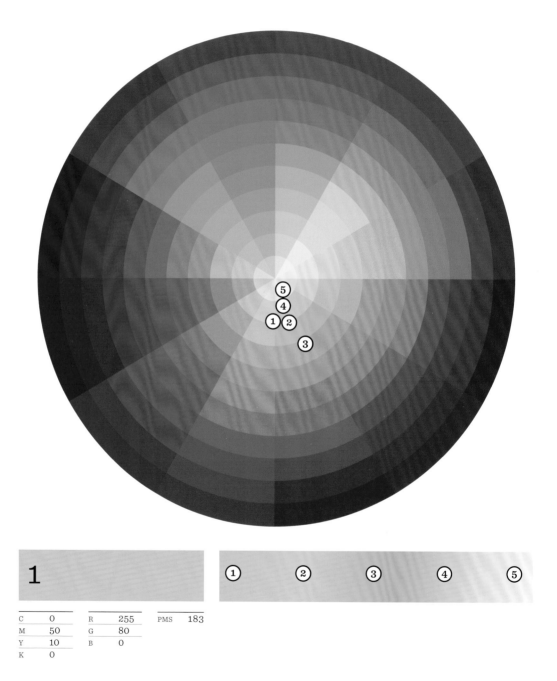

1

C	0	R	255	PMS	183
M	50	G	80		
Y	10	B	0		
K	0				

Palette Variations

1

C 0	C 0	C 0	C 0	C 30
M 50	M 80	M 60	M 85	M 70
Y 10	Y 60	Y 50	Y 0	Y 0
K 0	K 0	K 0	K 0	K 0

2

C 0	C 15	C 100	C 0
M 40	M 0	M 0	M 0
Y 20	Y 100	Y 0	Y 70
K 0	K 0	K 30	K 0

3

C 0	C 0	C 90	C 100	C 0
M 65	M 100	M 100	M 0	M 35
Y 25	Y 100	Y 15	Y 100	Y 100
K 0	K 0	K 0	K 0	K 0

4

C 0	C 60	C 40	C 20	C 25
M 30	M 0	M 0	M 0	M 0
Y 0	Y 40	Y 40	Y 20	Y 0
K 0	K 0	K 0	K 0	K 0

5

C 0	C 0	C 0	C 5
M 15	M 10	M 80	M 0
Y 0	Y 100	Y 80	Y 0
K 0	K 10	K 0	K 0

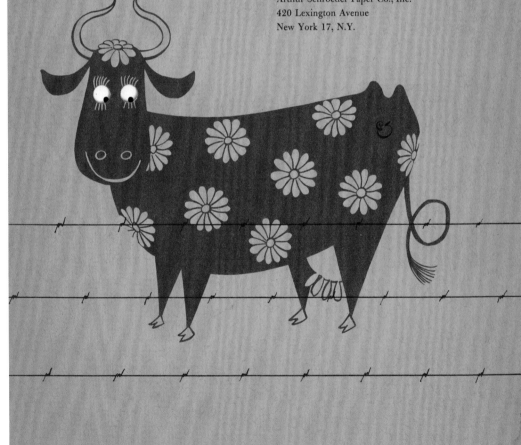

Purple

Purple \\pər-pəl
From Old English (describing the clothing of an emperor), from Latin *purpura*, from Greek *porphura*, regarding mollusks that yield a crimson dye

Due to its usage by royalty, Eastern religions, and Catholicism, purple carries the connotation of spirituality and aristocracy. Purple is a combination of two colors, red and blue. If the color contains more red, it will be warmer, brighter, and more intense. These shades can be used when a bright red is too garish. If it contains more blue, it will have a cooler and calmer effect.

Purple, with its connection to religion and politics, can be polarizing. Mid-range purple, equal blending of red and blue, tends to feel flat and uninteresting. Many designers use a version with either more red or blue to give the color depth and a point of view.

CULTURAL MEANINGS
In certain Native American tribal populations, purple represents wisdom. In Thailand, purple is worn by widows when mourning their husband's death. In Western culture, purple represents wealth and luxury. Pale purple, toward lavender, is connected to Easter. In the Roman age, only the emperor could wear purple. Those who disobeyed this law were condemned to death.

SUCCESSFUL APPLICATIONS
FedEx logo
Landor, 1994

Cadbury packaging
George Cadbury Jr., 1920

Winter Sunrise
Maxfield Parrish, 1949

OTHER NAMES
Amethyst
Aubergine
Grape
Lavender
Plum

OPPOSITE
Topsham Text
Unknown · 1962
Magazine advertisement
This advertisement for a line of paper uses a die cut for the fanciful purple cow's eyes. The pupils are created by two black dots printed on the following page of the magazine.

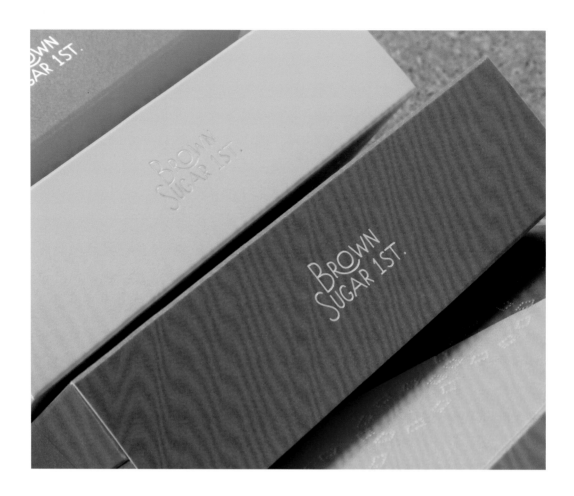

ABOVE
Brown Sugar 1st.
Keiko Akatsuka & Associates - 2016
Packaging
The packaging for the coconut cookies
made by Brown Sugar 1st. uses bright
colors, offset by a silver foil, to promote
a lively pop sensibility.

OPPOSITE
Los Angeles Forum for Architecture
Sean Adams - 1994
Book cover
Because of the budget, this poster was limited
to two colors. Rather than using purple as a
spot color only, the color overprinted a black
and white photograph of Florence Henri at the
Dessau Bauhaus.

Los Angeles Forum
for Architecture and Urban Design

The Green of Plant
Architecture without Buildings
Another spacey discussion
Architects who think they're artists
In Space
Inventing Space
The Brown of Dirt

Beyond Collaboration
Christopher Knight
LA Times Art Critic

Domestic Dialogues
Roy McMakin
Furniture Maker / Building
Designer

Installing Poetry
Amy Gerstler
Poet / Artist / Critic

Pure Prisms
James Carpenter
Light and Glass Artist

The Blue of Sky
Robert Millar
Public Art Artist

Schindler House
835 N Kings Road
W Hollywood, California 90089
213 852 7145

Teaching Architecture

BELOW
Elizabeth Taylor
Possibly Virgil Apger ~ 1958
(colorized by Olga Shirnina, 2014)
Photograph
Clothing can highlight certain colors in the
eyes. Elizabeth Taylor was often photo-
graphed wearing blue or purple eye shadow
to complement her eyes' purple-violet hue.

OPPOSITE
The National Health
Ken Briggs ~ 1969
Poster
Briggs created a specifically British approach
to modernism, including the introduction
of a more intense palette than the Swiss
International Style.

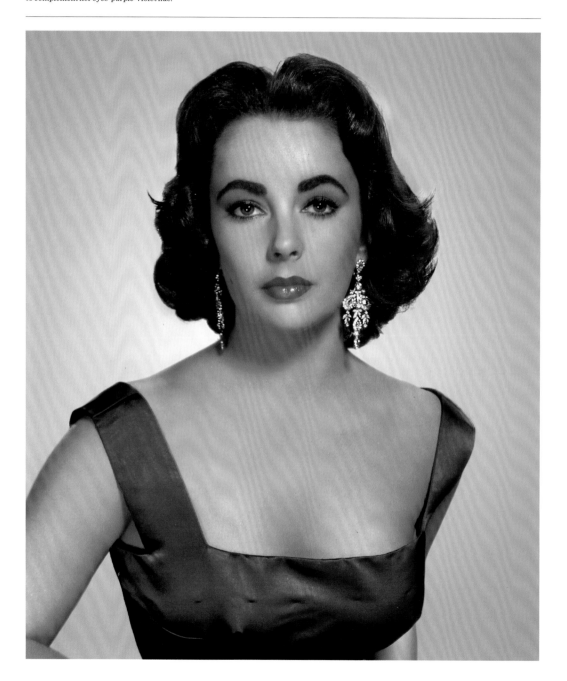

The National Theatre

The National Health or
Nurse Norton's Affair
Peter Nichols

Color Range

80

THE DESIGNER'S DICTIONARY OF COLOR

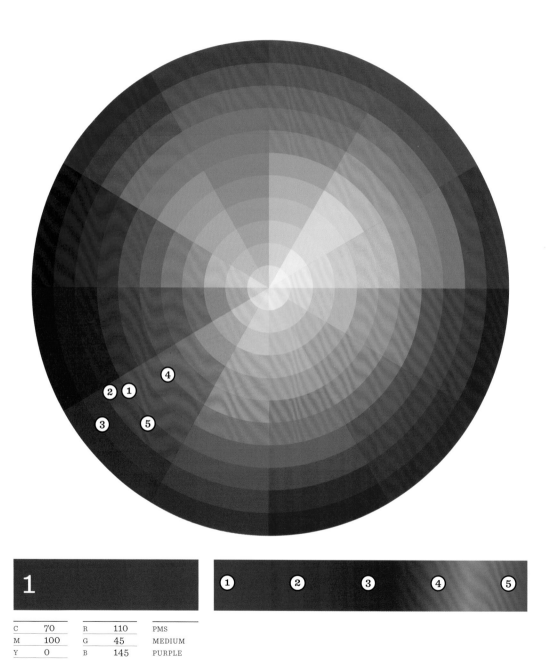

1						
C	70	R	110	PMS		
M	100	G	45	MEDIUM		
Y	0	B	145	PURPLE		
K	0					

Palette Variations

1

C	70	C	10	C	0	C	0	C	20
M	100	M	0	M	10	M	25	M	40
Y	0	Y	80	Y	100	Y	100	Y	100
K	0	K	0	K	0	K	0	K	0

2

C	90	C	0	C	0
M	100	M	70	M	100
Y	0	Y	100	Y	0
K	0	K	0	K	0

3

C	70	C	0	C	25	C	90	C	100
M	100	M	0	M	80	M	100	M	70
Y	0	Y	100	Y	100	Y	15	Y	0
K	50	K	50	K	15	K	0	K	0

4

C	40	C	0	C	25
M	60	M	50	M	0
Y	0	Y	20	Y	0
K	0	K	0	K	0

5

C	50	C	0	C	0	C	0	C	0
M	100	M	0	M	0	M	0	M	0
Y	0	Y	0	Y	0	Y	0	Y	0
K	0	K	25	K	50	K	75	K	100

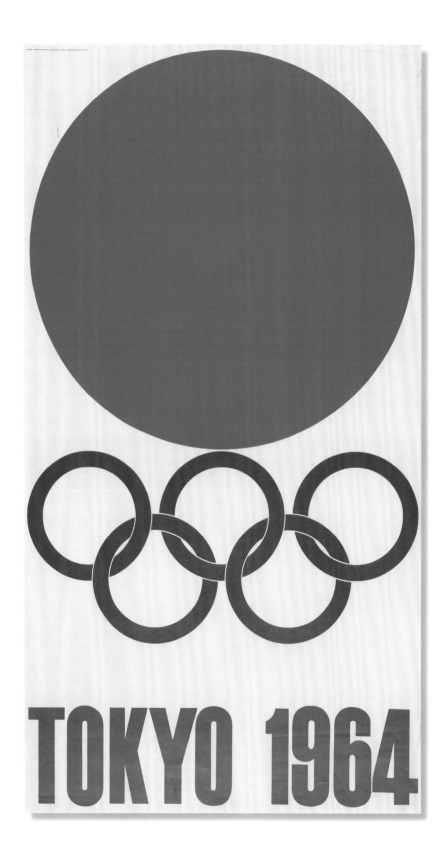

Red

Red \\red
From Old English *rēad*, of Germanic origin, related to Dutch *rood* and German *rot*, from an Indo-European root shared by Latin *rufus*

Red is radical. It is extreme, representing passion, energy, fire, violence, and anger. It is vibrant and creates contrast, demanding the viewer's attention. As the color of fire and blood, it is connected at a visceral level to our ideas of the energy of life. Red is a pure color; no other colors can be combined to create it. Designers use red as a loud shout. Stop signs, the Nazi swastika, and Coca-Cola cans are red.

The color can dominate an environment. Many designers shy away from such an extreme color, but red is one of a designer's most valuable tools to create dynamic contrast.

CULTURAL MEANINGS
In Asia, red is the color of good luck. It is the most popular color in China, but be aware: there is a difference between a Chinese red and red in other Asian cultures. In India, brides wear red saris. In Western culture, its meaning is connected with its companions. Red, white, and blue appear patriotic. Red, yellow, and blue, as primary colors, convey a juvenile message. Red and black can communicate fascism.

SUCCESSFUL APPLICATIONS
Coca-Cola red
Coca-Cola Company, 1900

9 West 57th Street sculpture
Chermayeff and Geismar, 1974

Virgin Airlines logo
Sir Richard Branson, 1970

OTHER NAMES
Apple Red
Crimson
Fire
Rose
Ruby

OPPOSITE
Tokyo Olympics
Yusaku Kamekura - 1964
Poster
Kamekura's poster for the 1964 Olympics is a perfect symphony of golden ratio proportions and minimal symbols. The red circle from the Japanese flag integrates flawlessly with the Olympic rings.

BELOW
NASA
Danne & Blackburn ~ 1974
Logo
The NASA logo is a warm shade of red,
an active color that brings kinetic energy
to the letterforms and references the
future-oriented nature of NASA.

OPPOSITE
California Academy of Sciences
Studio Hinrichs ~ 2010
Signage
The red entrance sign for the Academy build-
ing complements the architecture and serves
as a bold structure denoting the building's
primary entrance.

84

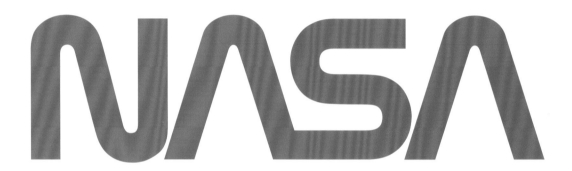

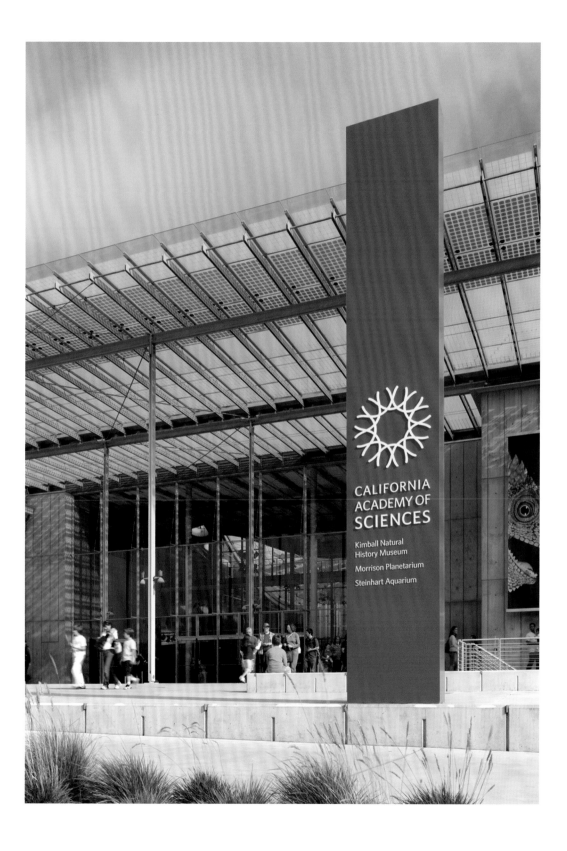

Modern Art
Bruce Rogers ~ 1896
Book cover (detail)
As a leader in the arts and crafts movement, Rogers references medieval letterforms and shapes with the deep scarlet tones of stained-glass windows.

El Museo Mexicano
Morla Design ~ 1995
Poster
Borrowing from Mexican high and low culture, Morla Design uses symbols, street sign typography, and a large red close-up of Frida Kahlo. The palette here is connected more to Mexico than Europe.

86

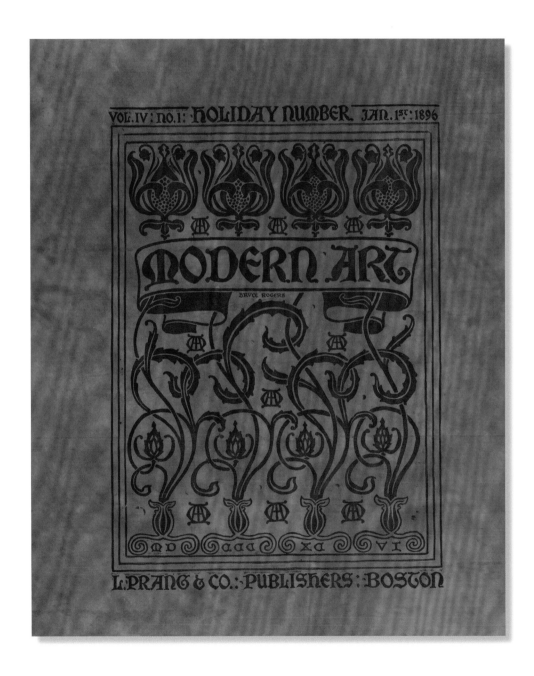

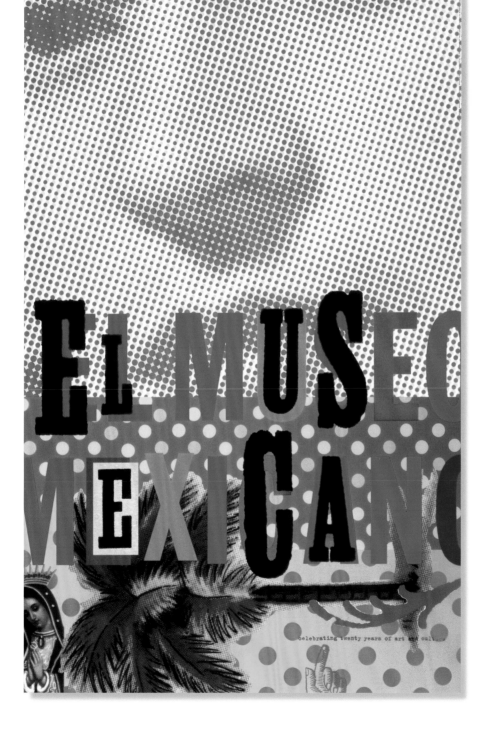

EL MUSEO MEXICANO

celebrating twenty years of art and culture

BELOW
Herman Miller Comes to Dallas
George Tscherny ~ 1955
Poster
The solid red color is connected to Herman
Miller's brand identity. The communication
is a series of simple symbols: red, cowboy hat,
and chair, leading to the "punch line."

OPPOSITE
Outlaw
Studio Uwe Loesch ~ 2002
Poster
Designed for the International Red Cross of
China, the smallest details of red command
the most attention as the only elements of the
poster in color.

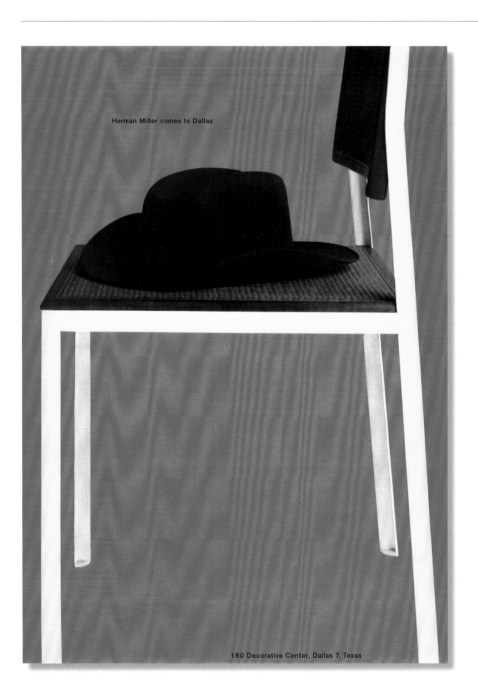

Herman Miller comes to Dallas

180 Decorative Center, Dallas 7, Texas

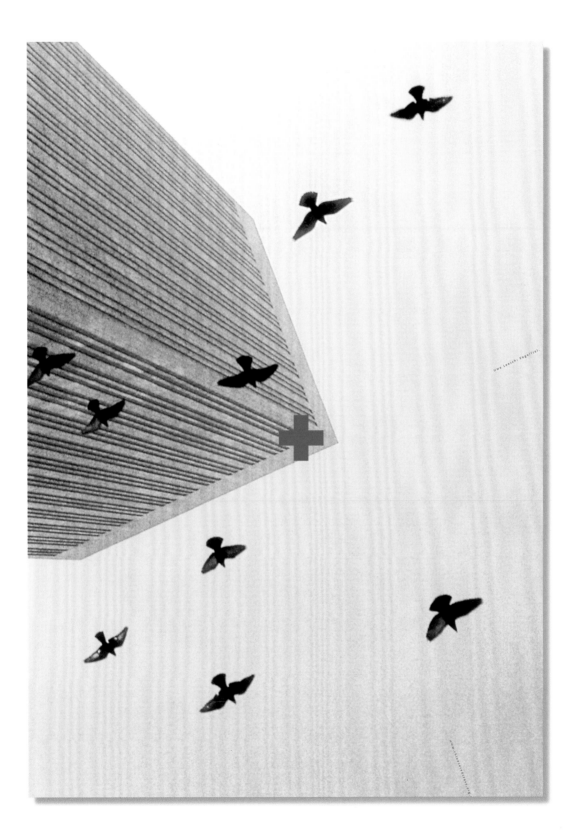

Uwe Loesch: Vogelfrei.

RED

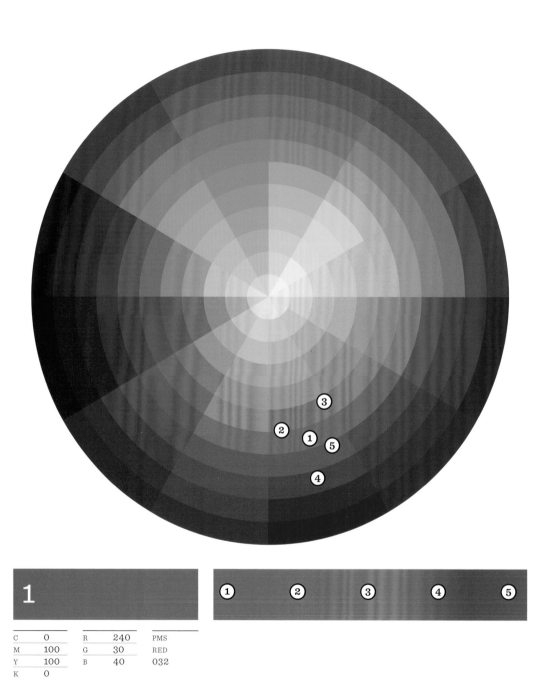

1				
C	0	R	240	PMS
M	100	G	30	RED
Y	100	B	40	032
K	0			

Palette Variations

1

C	0	C	0	C	0	C	0	C	0
M	100	M	50	M	80	M	100	M	25
Y	100	Y	100	Y	60	Y	0	Y	100
K	0	K	0	K	0	K	0	K	0

2

C	0	C	0	C	100	C	0	C	0
M	100	M	10	M	50	M	0	M	0
Y	70	Y	100	Y	0	Y	0	Y	0
K	0	K	0	K	0	K	50	K	100

3

C	0	C	0	C	0	C	0	C	0
M	90	M	0	M	0	M	0	M	0
Y	100	Y	0	Y	0	Y	0	Y	0
K	0	K	25	K	50	K	75	K	100

4

C	0	C	0	C	25	C	0	C	90
M	100	M	0	M	80	M	0	M	100
Y	100	Y	100	Y	100	Y	0	Y	15
K	30	K	50	K	15	K	75	K	0

5

C	0	C	25	C	5	C	40	C	0
M	100	M	15	M	0	M	50	M	10
Y	80	Y	60	Y	50	Y	100	Y	100
K	20	K	0	K	0	K	0	K	10

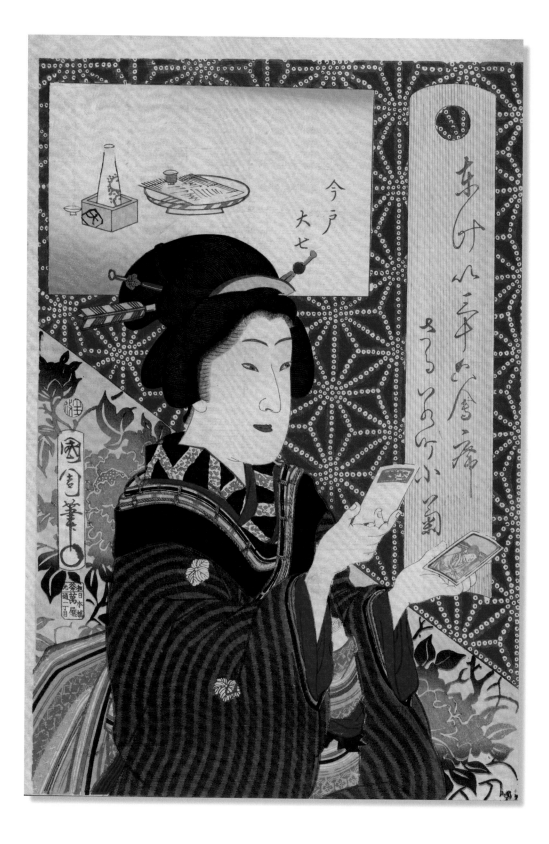

Scarlet

93

Scarlet \ˈskär-lət

Middle English (originally denoting any brightly colored cloth) shortening of Old French *escarlate*, from medieval Latin *scarlata*, via Arabic and medieval Greek from late Latin *sigillatus*

Scarlet is dangerous. It is a deeper and more intense color than primary red. If red communicates energy and fire, scarlet communicates danger, passion, seduction, and power. It's a color that works well to grab attention and demand respect. As a design tool, it sits in a mid-range value, allowing type to be overprinted in black or knocked out to white. Scarlet is also less likely to vibrate against a color such as blue.

Power is a prominent association with scarlet. Roman emperors used scarlet as a color of prestige. It is the color worn by Catholic cardinals. It is also the color of the benches in the British House of Lords.

CULTURAL MEANINGS

Nathaniel Hawthorne's *The Scarlet Letter* connected scarlet with adultery. In the Bible, the Whore of Babylon rides on a scarlet beast. Scarlet is also associated with education. In the United Kingdom, scarlet is the traditional color of a robe for people awarded a doctorate degree.

SUCCESSFUL APPLICATIONS
BBC News logo
Red Bee Media, 2005

Flag of the Soviet Union
First Congress of Soviets of the USSR, 1923

Scarlet Witch character
Stan Lee and Jack Kirby, 1964

OTHER NAMES
Brick
Burgundy
Caliente
Dark Red
Flaming Red

OPPOSITE
Saruwaka-cho Kogiku
Kunichika Toyohara- 1878
Print
Ukiyo-e print showing a beautiful woman, Kogiku, looking at photographic portraits (*cartes de visite*), possibly of her admirers. The introduction of analine red dyes in Japan made printing red and scarlet more intense and permanent.

Small Dot Pattern
Ray Eames ~ 1955
Textile
Inspired from colors in Asia and India,
Eames's Small Dot demonstrates her view
that color was not only an aesthetic technique
but also a means of conveying information
about objects and volumes.

The Marriage of Bette and Boo
SpotCo ~ 2008
Poster
Using scarlet as a symbol for love, Gail
Anderson creates an energetic and gestural
poster communicating the levity of the play.

94

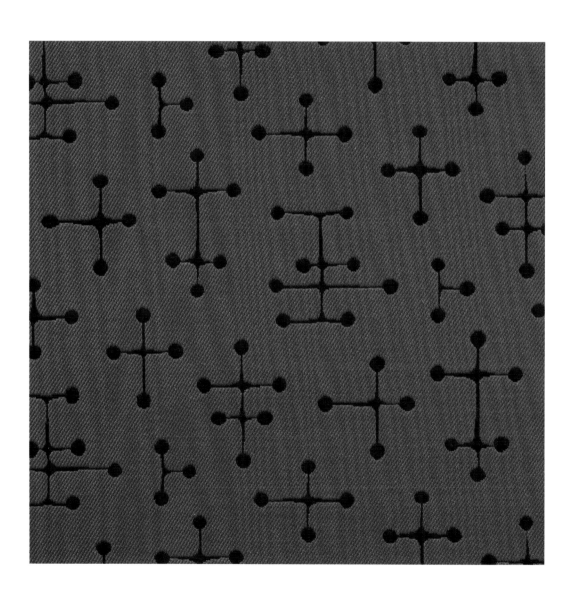

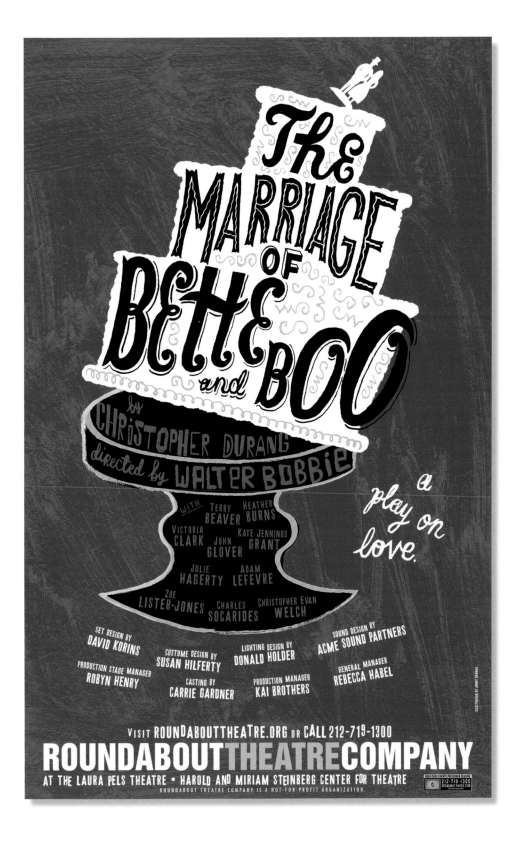

Hische's book cover for a reissue of Bram Stoker's *Dracula* moves beyond the expected bright red, and pushes the color to a more dangerous and "bloody" scarlet.

Early 20th-century printing required a second pass on the presses to print this deep red background. This resulted in an intense color, but sharp edges to the images and typography.

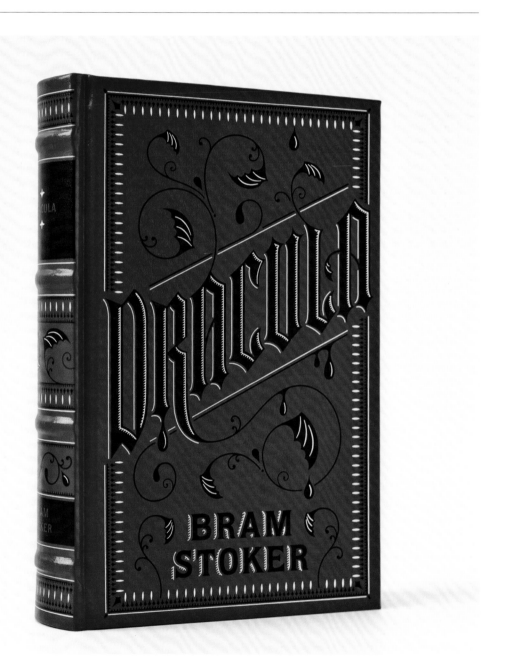

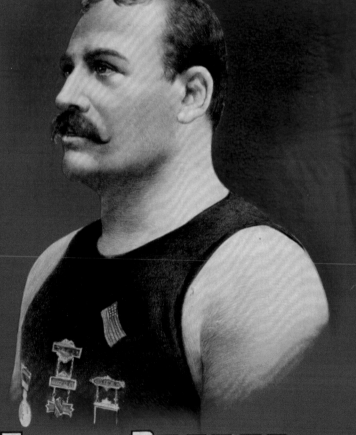

1				

C	0	R	200	PMS	1805
M	100	G	20		
Y	100	B	30		
K	20				

Palette Variations

1

C	0		C	30		C	0		C	25
M	100		M	0		M	90		M	80
Y	100		Y	100		Y	100		Y	100
K	20		K	60		K	0		K	15

2

C	0		C	90		C	100
M	100		M	100		M	70
Y	80		Y	15		Y	0
K	30		K	0		K	0

3

| C | 0 | | C | 0 | | C | 0 | | C | 0 | | C | 0 |
|---|---|---|---|---|---|---|---|---|---|---|---|---|---|---|
| M | 100 | | M | 0 | | M | 0 | | M | 0 | | M | 0 |
| Y | 100 | | Y | 0 | | Y | 0 | | Y | 0 | | Y | 0 |
| K | 50 | | K | 25 | | K | 50 | | K | 75 | | K | 100 |

4

C	50		C	50		C	30		C	0
M	100		M	40		M	0		M	0
Y	100		Y	100		Y	70		Y	100
K	0		K	10		K	0		K	80

5

| C | 0 | | C | 0 | | C | 0 | | C | 0 | | C | 0 |
|---|---|---|---|---|---|---|---|---|---|---|---|---|---|---|
| M | 100 | | M | 100 | | M | 70 | | M | 100 | | M | 60 |
| Y | 80 | | Y | 0 | | Y | 100 | | Y | 70 | | Y | 50 |
| K | 30 | | K | 0 | | K | 0 | | K | 0 | | K | 0 |

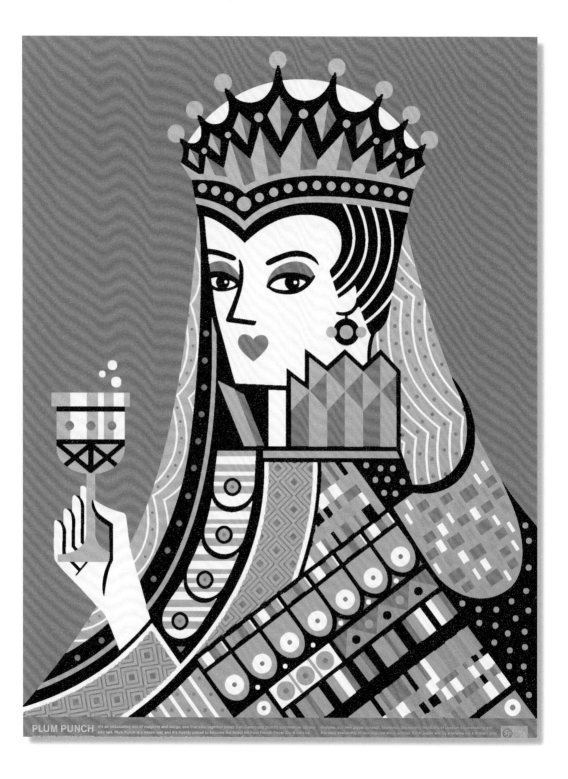

PLUM PUNCH It's an intoxicating mix of magenta and indigo, one that sips together tones simultaneously punchy and mellow, clingy and tart. Plum Punch is a knock-out, and it's freshly picked to become the latest hit from French Paper Co. It may be.

Violet

Violet \\ˈvī-(ə-)lət
Middle English, from Old French
violette, diminutive of *viole,*
from Latin *viola*

Spectral violet is the shortest wavelength, one step away from ultraviolet, which is invisible to the human eye. Violet light has the highest energy of any color. It is a color between royal purple and magenta. This tight balance makes violet dynamic. The viewer is engaged by solving the problem of deciding if it is magenta or purple. Designers use violet to create a sense of drama that might be lost with a flat purple color.

Violet ink is sensitive to UV light. It is often the first color to fade to blue when exposed to sunlight. As an in-between color, it is important to monitor the printing process and confirm the correct color is printing. A slight addition of cyan will create purple.

CULTURAL MEANINGS
Eastern religions equate violet with the crown chakra, the connection to a higher power. Cleopatra used violet as the official imperial color. The Japanese use violet to communicate wealth and power. In Western culture, violet is considered a feminine color, referring to a girl's name.

SUCCESSFUL APPLICATIONS
Yahoo logo
Ogilvy, 2004

Violet Beauregarde character,
Willy Wonka and the Chocolate Factory
Mel Stuart, 1971

OTHER NAMES
Hydrangea
Lilac
Mauve
Orchid
Pastel Purple

OPPOSITE
Plum Punch
Charles S. Anderson Design Co. - 2012
French Paper advertisement
A poster promoting a line of paper for French Paper. These colors often coordinate with current trends and are inspired by the French Custom Color Vault, a library of every French Paper product made since 1871.

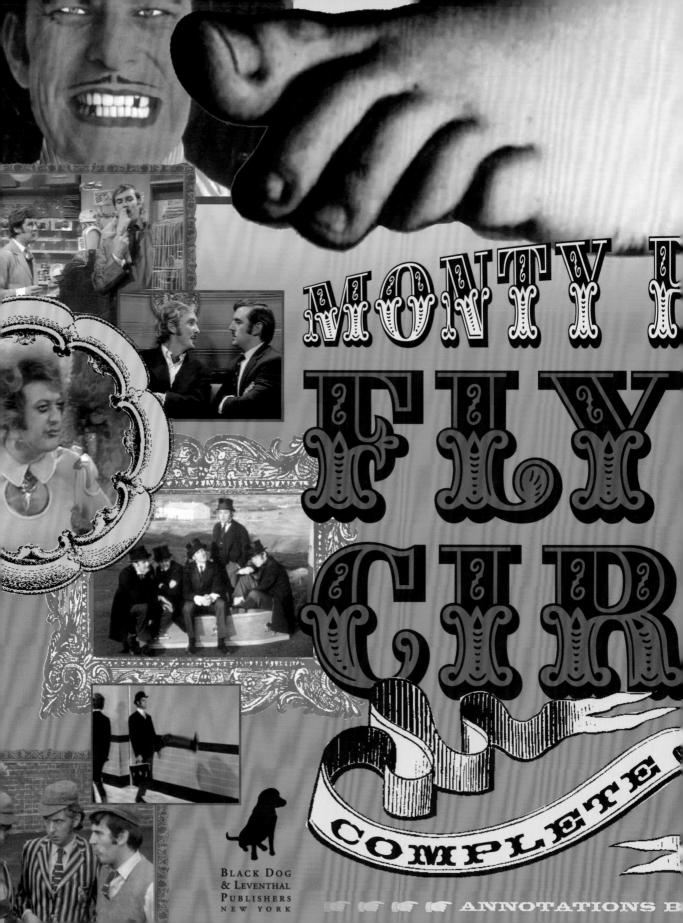

MONTY P

FLY

CIR

COMPLETE

BLACK DOG
& LEVENTHAL
PUBLISHERS
NEW YORK

ANNOTATIONS B

YTHON'S

ALL THE BITS

LYING CIRCUS

ANNOTATED AND

8 ½

DESIGN
EIGHT AND A HALF
BROOKLYN
NEW YORK

LUKE DEMPSEY

Monty Python's Flying Circus
Eight and a Half, New York, Ltd. ~ 2014
Book

Bonnie Siegler uses a double spread of the cut-out animations of Terry Gilliam's vibrantly colored opening titles, featuring the iconic giant foot that became a symbol of all that was "Pythonesque."

ArtCenter MGx
Sean Adams ~ 2016
Promotional booklet

Designed to promote the ArtCenter graduate program in graphic design, the MGx book incorporates quotes from notable designers on a variety of issues. Silhouettes, rather than photographs, identify each designer.

Palette '61
Jack Lenor Larsen, Inc. ~ 1961
Catalog

The Larsen Design Studio created modern fabrics for interior and industrial use. Their innovations with color, handwoven textiles, and fabrics, in scale with modern architecture, changed the industry.

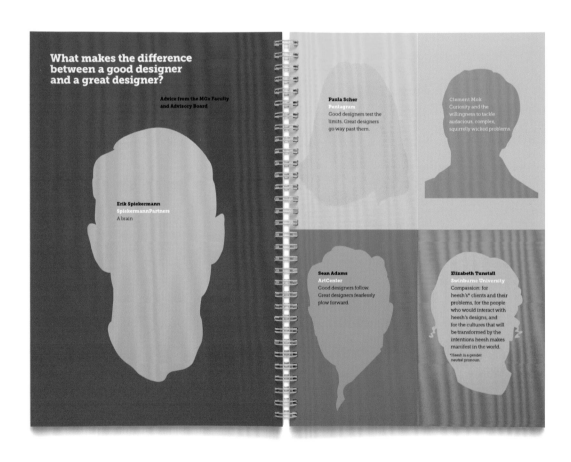

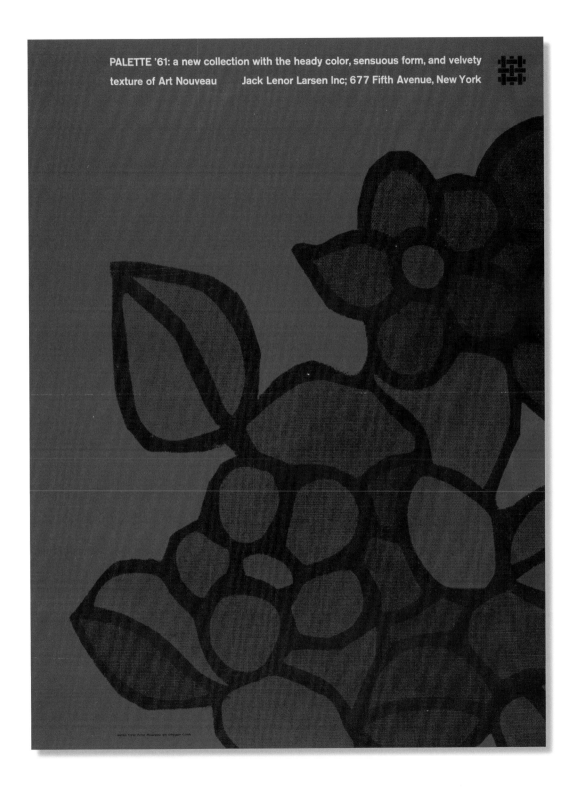

PALETTE '61: a new collection with the heady color, sensuous form, and velvety texture of Art Nouveau Jack Lenor Larsen Inc; 677 Fifth Avenue, New York

1						
C	30	R	180	PMS		
M	100	G	30	PURPLE		
Y	0	B	140			
K	0					

Palette Variations

1

C	30	C	0	C	0	C	0	C	50
M	100	M	70	M	100	M	10	M	0
Y	0	Y	100	Y	0	Y	100	Y	100
K	0	K	0	K	0	K	0	K	0

2

C	50	C	70	C	60	C	0	C	0
M	100	M	0	M	0	M	0	M	0
Y	0	Y	0	Y	40	Y	100	Y	100
K	0	K	0	K	0	K	0	K	50

3

C	20	C	0	C	0	C	0	C	0
M	100	M	0	M	0	M	0	M	0
Y	0	Y	0	Y	0	Y	0	Y	0
K	0	K	25	K	50	K	75	K	100

4

C	40	C	10	C	10	C	0	C	0
M	100	M	10	M	0	M	50	M	0
Y	30	Y	20	Y	50	Y	20	Y	0
K	0	K	0	K	0	K	0	K	25

5

C	30	C	90	C	100	C	0	C	0
M	70	M	100	M	70	M	100	M	100
Y	0	Y	15	Y	0	Y	0	Y	100
K	0	K	0	K	0	K	0	K	0

Yellow

Yellow \\ye-()lō
From Old English *geolu*, *geolo*, of West Germanic origin, related to Dutch *geel* and German *gelb*, also to "gold"

Yellow is a primary color that cannot be created with other colors. It is universally regarded as cheerful, representing happiness, sunlight, optimism, and creativity. Yellow can be used to create a bold contrast with other colors. It works well as a replacement for gray when the goal is vibrancy. Many designers fear knocking type out of yellow to white, but this works when enough magenta (at least 20%) is mixed with the yellow.

Yellow and black create avocado green. Therefore, used as a second duotone color or overprinted on black and white it will create a sickly greenish tone.

CULTURAL MEANINGS
In Japan, yellow represents courage. In China, only the emperor was permitted to wear yellow. A yellow patch was used to label Jews during the Middle Ages, and European Jews were forced to wear yellow "Stars of David" by the Nazis. Negative connotations include cowardice; for example, a cowardly person might be described as "yellow."

SUCCESSFUL APPLICATIONS
Eros magazine cover
Herb Lubalin, 1962

UCLA Extension poster
Sean Adams, 1998

Smiley face symbol
Harvey Ross Ball, 1963

OTHER NAMES
Amber
Banana
Canary
Corn
Lemon

OPPOSITE
IBM Selectric
Wolff Olins, Su Murphy ~ 2014
Poster
IBM blue is offset with a cheerful and optimistic solid tone of yellow. The intensity and vast amount of the color leave no doubt that this is a positive and upbeat message.

"A ZESTFUL, RACY MUSICAL. A GRAND SHOW!" —CHAPMAN
N. Y. DAILY NEWS

TENDERLOIN

A NEW MUSICAL COMEDY

ROBERT E. GRIFFITH & HAROLD S. PRINCE

present

MAURICE EVANS

in

*

Based on the novel by Samuel Hopkins Adams

with

RON HUSMANN

WYNNE EILEEN
MILLER RODGERS

REX EDDIE LEE
EVERHART PHILLIPS BECKER

RALPH RAYMOND ROY IRENE
DUNN BRAMLEY FANT KANE

Book by

GEORGE and **JEROME**
ABBOTT **WEIDMAN**

Music by

JERRY BOCK

Lyrics by

SHELDON HARNICK

Dances and Musical Numbers Staged by

JOE LAYTON

Sets and Costumes by

CECIL BEATON

Musical Direction Orchestrations Dance Music Arranged by
HAL HASTINGS IRWIN KOSTAL JACK ELLIOTT

Production Directed by

GEORGE ABBOTT

Original Cast Album by Capitol Records

"THAT'S ENOUGH! TWO INCHES IS JOURNALISM!
ANYTHING MORE IS SMUT!"

"EVEN MONEY ON THE RED GARTERS!"

"WHY DON'T THEY HAVE BABIES DOWN THERE?"

"WITH GOD'S HELP WE SHALL WIPE OUT THIS
CESSPOOL OF VICE CALLED THE TENDERLOIN!"

*TENDERLOIN—A SECTION IN NEW YORK CITY DEVOTED TO
VICE AND LAWLESSNESS. (So called the "Best Cut of Graft.")

46th STREET THEATRE 226 WEST 46th STREET, NEW YORK, N.Y.

OPPOSITE
Tenderloin
Robert Graves ~ 1961
Poster

This poster for a musical comedy integrates Victorian typography and imagery, a modernist grid structure, and 1960s psychedelic color palette of yellow and fluorescent red.

BELOW
Nuts.com
Pentagram, Michael Bierut ~ 2013
Packaging

Embracing the company's friendly attitude and "nutty" name, Bierut designed a palette of hand-drawn letterforms and bright colors with yellow as a center-point for the brand.

PAGES 112–113
PAVE School
Pentagram, Paula Scher ~ 2010
Cafeteria wall mural

For an elementary school, Scher incorporated success-oriented language into a luminous yellow-tiled wall. The goal is to explain what success can be—"Sloganeering," as Scher explains.

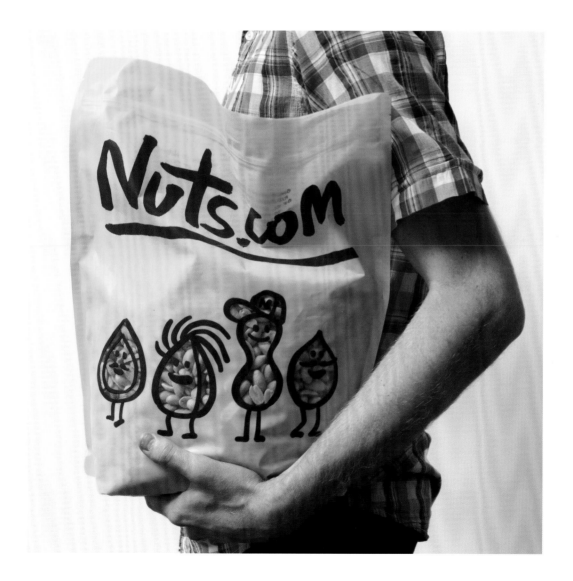

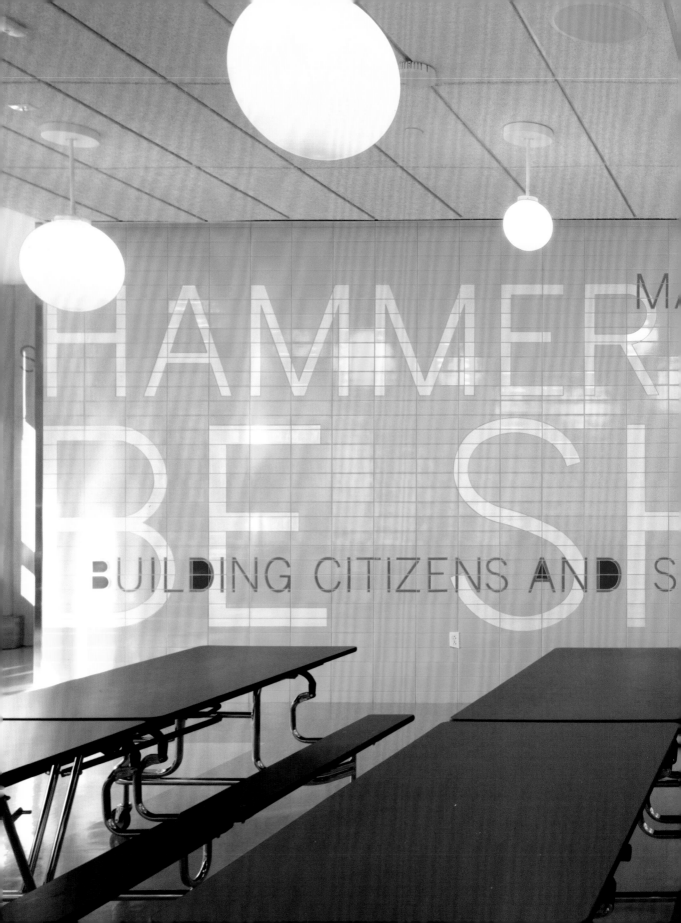

RATHON MINDSET

THE HOME

HARD

HOLARS-BRICK BY BRICK

114

Data 595

Data Processing Systems, Equipment & Supplies (Cont'd)

EVANS & SUTHERLAND COMPUTERS

EVANS & SUTHERLAND COMPUTERS MANUFACTURERS OF DIGITAL DISPLAY PROCESSORS AND SYSTEMS

"FOR INFORMATION CALL"

MANUFACTURERS

EVANS & SUTHERLAND COMPUTER CORP
3 Research Rd
SaltLakeCityUtah.801 322-5847

EXECUTIVE OFFICE EQUIP—

BUY & SELL - USED
IBM - FRIDEN
N.C.R., BURROUGHS & OTHERS
EDP MACHINES & SUPPLIES
SALES & SERVICE
21 N Marengo Pas..........684-1776

Fabri-Tek Memory Products Division
8820 Sepulveda.776-6420

FACIT DATA RECORDING EQUIPMENT

• I/O Typewriters • Adding Machines and Typewriters with output • Mag tape recorders • Strip Printers • Paper tape readers, Punches, Reproducers • OEM Equipment Sales

"WHERE TO BUY THEM"

BRANCH OFFICE

FACIT-ODHNER INC
2206 Beverly.387-6117

Farrington Manufacturing Company
3345 Wilshire.380-6831
Friden Division The Singer Co
Point of Transition Systems
825 S Hoover-380-3317
GENERAL BINDING SALES CORP
7308 La Cienega Bl Ing.678-1124
GENERAL BUSINESS FORMS
SAFEGUARD DATA SYSTEMS INC
Designers & Manufacturers
Of Business Forms
Plant 10320 Vacco SElMonte.686-1575
2330 W 3rd..........380-3860
General Computers Inc
5990 W Pico.939-7687
GENERAL ELECTRIC CO

INFORMATION SYSTEMS SALES AND SERVICE

"FOR INFORMATION CALL"
General Electric Company
3810 Wilshire.386-8220

GENERAL ELECTRIC COMPANY
Sales
3810 Wilshire..........386-8220
GLOBE TICKET COMPANY
Data Processing Cards-Computer Labels
2787 E Del Amo Cpt..........774-4210
GRAHAM MAGNETICS INC
3111 Los Fellz.666-4034

Telephone men in all parts of the Bell System have had long experience in working together. Tools, equipment, methods of tackling the job and the "language of the business" are the same north or south, east or west. This nationwide unity of method and spirit means a telephone service of the utmost dependability.

GRANITE DATA SERVICES CORP

MASTER COMPUTER CENTER
• Equipment: Purchase, Sale or Lease
 I.B.M. 360 Specialists
• Service Bureau: Batch, Job or Time
 Quick Turnaround
• Software: Pre-Packaged or
 Custom Designed
• Installation: Turnkey Installed
 360/20, Unit Record
• Training: Programming, Operations
 Systems.

GRANITE DATA SERVICES CORP
661 S Burlington.483-6921

GREYHOUND COMPUTER CORPORATION

Subsidiary of Greyhound Corporation
COMPUTER-LEASING
2nd & 3rd Generation
Western Region Headquarters
6151 W Century..........776-1567

GULTON INDUSTRIES INC COMPUTER—

Hard Copy
KSR-ASR
Terminals
Magnetic Cassette
Incremental Recorder
OEM Sales - Lease Arrangements
Illustrated Brochure Available

GULTON INDUSTRIES INC
COMPUTER SYSTEMS DIV
13041 Cerise Haw.679-0111

H P S
Computer Room Air Conditioning
5082 Alhambra..........221-5273
HEWLETT-PACKARD NEELY SALES REGION
Serving Los Angeles-Sn Fernando Vly
3939 Lankmtm NH..........877-1282
Serving Orange Co-Riverside-Downey
1430 E Orangethorpe
Fullerton.714 870-1000
Holtzman Office Furniture Co
1417 S Figueroa.749-7021
HONEYWELL ELECTRONIC DATA PROCESSING SYSTEMS—

REGIONAL SALES OFFICE

HONEYWELL INC
Electronic Data Processing Division
444 West Ocean LB..........435-6578

Honeywell Inc
Data Systems Div
444 W Ocean LB.775-8941
Electronic Data Processing Div
700 Wilshire.625-1271
IBM CORP
Other Offices
L A Parts Center
690 Wilshr Pl.386-8821
Sales
Glendale Br Ofc
1031 N Brand Gln.245-8445
Inglewood Br Ofc
9045 Lincoln.776-3931
L A Downtown Data Processing
445 S Figueroa.620-1830
L A Metropolitan West-New Business
3550 Wilshire.382-7272
Santa Monica Data Processing
606 Wilshire SantaMonica.870-9411
Service-Elec Typewriter & Dictation
Equip
Beverly Hills
8979 Wilshire..........380-6080
L A Downtown 624 S Grand..380-5404
L A East
6055 E Washington Bl.685-8105
(Continued Next Column)

Sales Come from Phone Calls
Be Sure Your Phones Are Answered

IBM CORP (Cont'd)
Service-Data Processing Field
Engineering Division
L A Metropolitan
Service Data Processing....385-5254
L A Midtown
Service Data Processing...628-7286
L A Northeast
6055 E Washington Bl.723-2561
Service Data Processing
6055 E Washington Bl.685-9390
L A South
3777 Long Beach Bl LB.636-3228
L A West
Service Data Processing....776-1454
I O A DATA CORP
Complete Range of IBM
From 024 to 360 Sales, Rentals
383 Lafayette New York
NewYork.212 673-9300
Incorporated Management Systems
15300 Ventura ShOks.872-1722
Inforex Inc 6820 La Tijera......776-5865
INFORMATION DISPLAYS INC
15720 Ventura End.783-1560
INFORMATION MACHINES CORP
8811 Cuyamaco Santee.714 448-8811
INFOTECHNICS INC
15730 Stagg VN.780-3615
Interdata 8703 La Tijera........670-8386
Internatl Computer Equip Inc
11635 S Hawthorne Haw.772-1091
International Data Products......380-7645
INTERNATIONAL ELECTRONIC INDUSTRIES INC

We Lease - Sell
& Buy New & Used
Computer Systems
Components

Punch Card Equipment

"FOR INFORMATION CALL"
INTERNATIONAL ELECTRONIC INDUSTRIES INC
920 W Olympic.748-8521

International Software Corp
800 W 1st.680-0055
ISAACS JOHN & ASSOCIATES
1320 S Grand.749-1044
JACKSON EDWARDS CO

• COMPUTER TAPE
 RECERTIFICATION
• DISK PACKS
• MAGNETIC TAPE
 CLEANERS AND
 CERTIFIERS
COM Microfilm Service

"WHERE TO CALL"
JACKSON EDWARDS CO
4101 Lankershim NH.877-9603

JENKINS INDEX CORP
2369 Yates.685-6750
KENNEDY CO
540 W Woodbury Rd Alt.681-9314
Langan Aperture Cards Inc
265 Marguerita Ln Pas.682-1887
LEVIN-TOWNSEND COMPUTER CORP
1901 Avenue Of The Stars LA.277-3211
LIEBERT FLOR-FLO SYSTEMS—
HORSEFIELD & SECORD
4119 San Fernando Rd Gln.245-1233

Linnell Electronics..........772-3351
LOCKHEED ELECTRONICS COMPANY
8301 E Florence Dny.869-2091
LOGIC CORP 3440 Wilshire.......380-6733
MDS DATA PROCESSING INPUT & OUTPUT EQUIPMENT—

SALES

MOHAWK DATA SCIENCES CORP
3324 Wilshire.380-1100

If you need help quickly,
the YELLOW PAGES
is the place to look.
Thousands of Services
and dealers are listed in
the YELLOW PAGES
for your quick reference.

March Litho Co
2928 Nebraska SantaMonica.870-9707
Marshall Data Systems
2660 Columbia Tor.775-7561
McLaughlin George S Associates
785 Springfield Av Summit
NewJersey.201 273-5464
MEMOREX CORP
Information Media Group
1047 Gayley LA..........477-1018
Memorex Equipment Group
3435 Wilshire.380-4790
MEMORY MAGNETIC INTERNATIONAL.772-3351
MODERN SERVICE OFC SUPPLY CO
Free Data Supl & Equip Cat on Request
1345 E 16th..........748-4171
MOHAWK DATA SCIENCES CORP
Service & OEM Sales
6252 Telegraph Rd..........685-4171
Mohawk Data Sciences Corp
O E M Sales 6252 Telegraph Rd.685-5165
Mohawk Data Sciences Corp
3324 Wilshire.380-1100
NASHUA COMPUTER SUPPLIES—
NASHUA CORP
Disc Packs
3037 Marla Cpt..........774-6660

National Blank Book
7th & Don Julian Ind.283-0937
National Cash Register Co The
Century City
Regional Executive Offices
1940 Century Prk East LA......879-2121
Downtown
1033 S Hope..........746-0610
From the following exchanges only
Compton
(No Charge) Ask Opr for...Zenith 2-7495
From the following exchanges only
Downey
(No Charge) Dial 110 for..Zenith 2-7495
NATIONAL DATA ASSOCIATES
1543 W Olympic.380-2312
(Please See Advertisement Page 593)
NATIONAL DATA PROCESSING BINDERS

EXCLUSIVE
FLEXIBLE
CABLE POSTS
EASY LOADING
TOP OR BOTTOM.
FOR BURST OR UNBURST FORMS.
Complete Line, Indexes & Perforator Tape

"WHERE TO BUY THEM"

DIVISIONAL OFFICE

NATIONAL BLANK BOOK
7th & Don Julian Industry.283-0937

DEALER

ISAACS JOHN & ASSOCIATES
1320 S Grand.749-1044
Modern Service Ofc Supply Co
1345 E 16th.748-4171
SAVEL COMMERCIAL STATIONERY CO
1216 Maple.749-1403

NOVATION

• Remote Computer
 Terminals
• Acoustic Couplers
• Computer Interface
 Designs
• Real Time Control
 Programs

"FOR IMAGINEERING CALL"
NOVATION INC
18664 Topham Tarz.344-7191

OBLIQUE FILING EQUIPMENT
Same as Speedtite Products.291-1405
Olivetti Corporation of America
1300 W 8th.385-2988

Two friendly telephone habits:
QUICK to answer when your bell
rings; SLOW to hang up when you
call someone who does not immediately answer. In calling others, remember that your party may be almost there—so wait a little longer.

OLIVETTI UNDERWOOD PROGRAMMA - 101
Desk-Top
Computer
Automatic
Printout
Programs Stored On
Magnetic Cards
SALES - SERVICE - SUPPLIES - LEASE

"FOR INFORMATION CALL"

ALL PRODUCTS—SALES

OLIVETTI CORPORATION OF
AMERICA 1300 W 8th.382-8171

ALL PRODUCTS—SERVICE

OLIVETTI CORPORATION OF
AMERICA 1300 W 8th.384-4181

On-Line Computer Systems Inc
3345Wilshire.381-6072
Optical Scanning Corp
3130 Wilshire.380-1771
PACIFIC TELEPHONE
740 S Olive.621-8899
Peripheral Data Machines Inc
1546 E Chestnut SantaAna.628-0061
Poe E D & Associates
10711 Wellworth.272-6052
POTTER INSTRUMENT

Data Processing,
Computer Peripheral systems
and Equipment.
Tape Transports, Tape Readers, Memories, High-Speed Chain Printers. Precision Coordinate Measuring Machines.

"FOR INFORMATION CALL"
Potter Instrument Co Inc
715 E Mistn Dr SGab.283-8177

PRECISION INSTRUMENT CO
Digital Recording Equipment
4032 Wilshire..........380-5880
RCA CORPORATION
COMPUTERS
HARDWARE - SOFTWARE
MARKETING & SERVICE
1730 W Olympic Bl..........385-2071
RCA CORPORATION
District Sales North
6363 W Sunset Hol..........461-9171
RANDOMATIC RETRIEVAL SYSTEMS—

DISTRIBUTOR

BUSINESS MACHINES &
COMPUTERS INC
1530 S Olive.747-0603

RAYTEE CO
Memory Discs & Computer Parts
761 E Slausn..........233-4261
RAYTHEON COMPUTER
Main Office
2700 S Fairvw SantaAna.....625-7645
District Sales Office
9550 Flair Dr EIM..........443-7181
Recognition Equip Co
3470 Wilshire.389-3178
Rixon Electronics Inc
8939 Sepulveda LA.776-1708
SABRE INDUSTRIES INC
Continuous Loop Tape Recorders
Mylar Belts & Related Equipt
Complete Design & Engineering Serv
519 S Flower Brb..........849-6081
SAFEGUARD DATA SYSTEMS INC
GENERAL BUSINESS FORMS DIV
Designers & Manufacturers
Of Business Forms
Plant 10320 Vacco SElMonte.686-1575
2330 W 3rd..........380-3860
Sangamo Electric Co
1543 W Olympic.380-3012
SCHOENNEMAN INC
FLEXOWRITERS
DATA PROCESSING EQUIP.
2901 Beverly..........385-6217
Scriptomatic Inc 2817 W Temple..381-5241
SHIRDON INC
See Our Ad under Labels
5156 Alhambra..........221-1998
(Continued Next Page)

Your calls cannot reach you if your receiver is off the hook. After each call, PLEASE carefully place the receiver on the hook.

Communication Arts
Bill Tara and Richard Coyne ~ 1971
Magazine cover

For an issue about corporate identity, Tara found an existing page from the *Bell Telephone Book* "Yellow Pages." The Yellow Pages was the section of the book devoted to businesses rather than residents.

FontShop
Erik Spiekerman ~ 1998
Website

FontShop is the premier retailer for desktop, web, and mobile typefaces, with over 150,000 fonts . Their proprietary color palette of black and yellow has identified the brand for over 25 years.

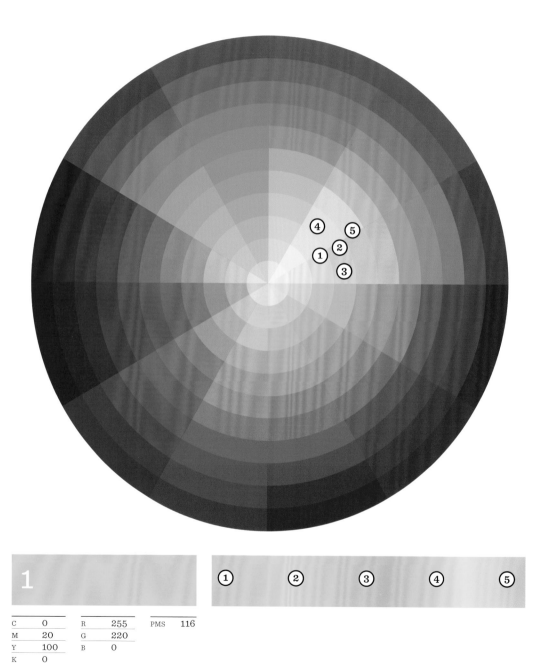

1					
C	0	R	255	PMS	116
M	20	G	220		
Y	100	B	0		
K	0				

Palette Variations

1

C	0	C	0	C	0	C	20
M	20	M	0	M	25	M	40
Y	100	Y	70	Y	100	Y	100
K	0	K	0	K	0	K	0

2

C	0	C	100	C	0	C	0
M	10	M	90	M	100	M	0
Y	100	Y	0	Y	100	Y	0
K	0	K	0	K	0	K	50

3

C	0	C	0	C	0	C	0	C	0
M	35	M	0	M	0	M	0	M	0
Y	100	Y	0	Y	0	Y	0	Y	0
K	0	K	25	K	50	K	75	K	100

4

C	0	C	10	C	25
M	0	M	0	M	0
Y	100	Y	50	Y	0
K	0	K	0	K	0

5

C	0	C	20	C	0	C	40	C	30
M	10	M	20	M	0	M	60	M	80
Y	100	Y	20	Y	20	Y	100	Y	100
K	10	K	0	K	75	K	30	K	60

Cool Colors

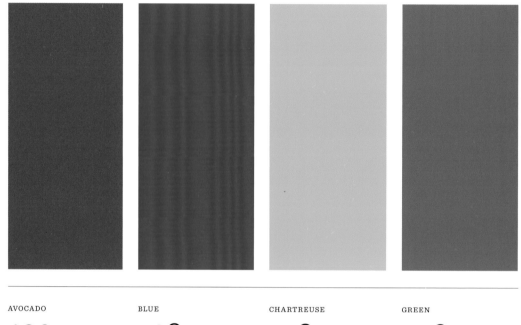

AVOCADO	BLUE	CHARTREUSE	GREEN
120	128	138	146

LIGHT BLUE	MINT	OLIVE	TURQUOISE
156	164	172	180

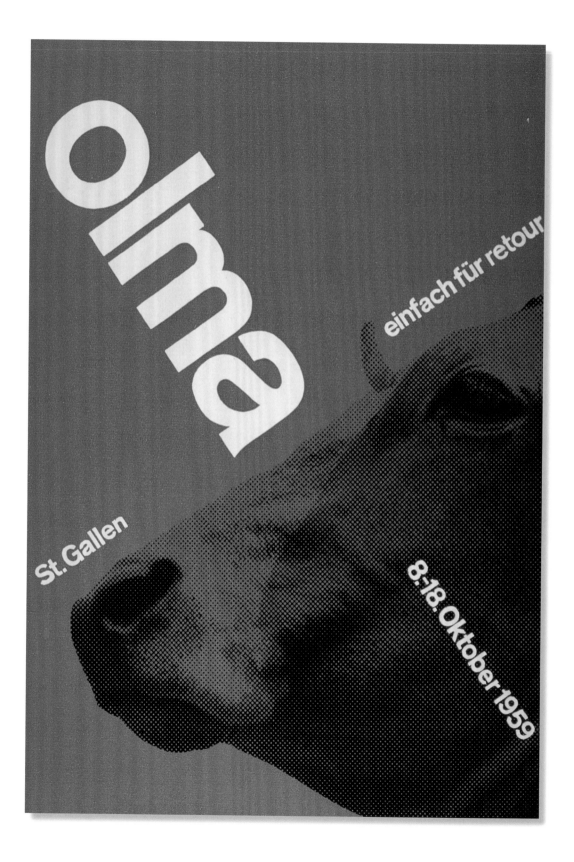

Avocado

Avocado \ ˌä-və-ˈkä-(ˌ)dō\
From mid-17th century, from Spanish, alteration (influenced by avocado, or "advocate") of *aguacate*, from Nahuatl *ahuacatl*

Avocado green is a dark green with more yellow than blue. While bright green may appear loud or abrasive, avocado is easier to manage. It feels restful to the viewer's eye as the eye's lens focuses green light exactly on the retina. It is a color that may be used to "cool down" a palette that is too sweet or hot.

As part of the secondary green family, avocado shares the subjective issues of orange. One person may love the tone, while another prefers a green that is more blue, or lighter. It also elicits strong opinions. The term "Avocado Green" may have associations with 1970s' appliances and cars. A safer description to use is "dark green."

CULTURAL MEANINGS
Avocado green represents new beginnings in New Age and mystical beliefs. In Western culture, it was used as a color for clothing, appliances, and automobiles in the 1970s to communicate nature. This was in response to the anticonsumerism ideas of the 1960s counterculture movement. If the station wagon is avocado green, it must be good for the Earth.

SUCCESSFUL APPLICATIONS
Kitchen appliances
1970s

Nauga Monster
George Lois, 1958

Grand Canyon Concourse mural
Mary Blair, 1971

OTHER NAMES
Pine
Seaweed
Juniper
Moss Green
Artichoke

OPPOSITE
Olma
Josef Müller-Brockmann ~ 1955
Poster
For an agricultural fair in St. Gallen, Switzerland, Müller-Brockmann applies a classic Swiss grid structure to an image of a cow.

Wit, Melody, & Essence Upholstery
Knoll, Inc.~2016
Textiles
The interplay between shades of brown, moss, ocher, and avocado creates a dynamic sense of movement on these textiles from Knoll. They are used here for pads on a Bertoia bench.

Tanaka Sharaku
Ikko Tanaka~1994
Poster
Ikko Tanaka merged Japanese traditional forms and colors with International Style Modernism. He reduced classic subjects to geometric shapes and emphasized sharp color contrast.

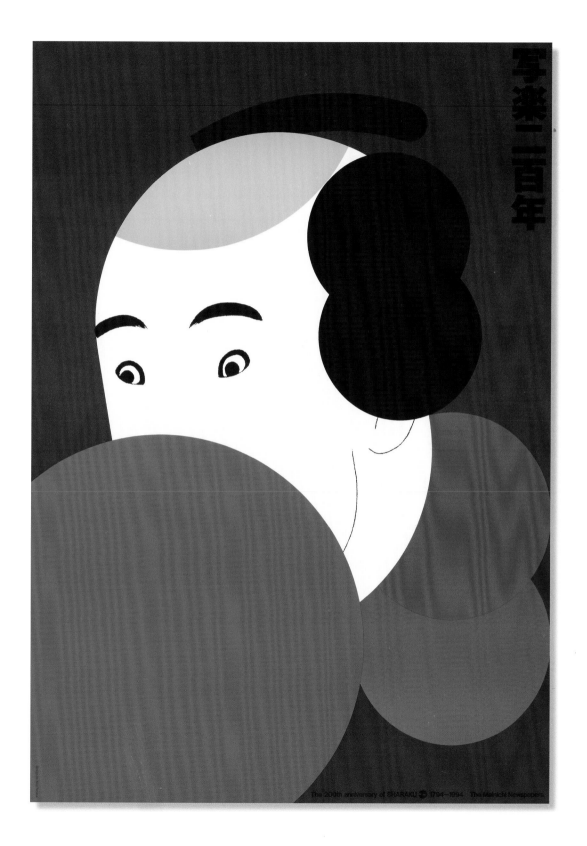

写楽二百年

AVOCADO

LeMans

One glance at the 1971 LeMans illustrates our belief
that even a modestly priced Pontiac can have a sporty look.
There's nothing to clutter up the lines. Even the windshield
wipers and radio antenna are concealed to keep the
design sleek and trim.

In the 1970s, Pontiac LeMans incorporated Shadow and Brasilia Gold, in reality both avocado green. The trend toward natural earth colors influenced all objects in the 1970s, from telephones to cars.

In the late 1940s, Charles and Ray Eames turned to organic forms with new materials. The result was the Eames Fiberglass Chair. RAR stands for rocker height, armchair, rocking base

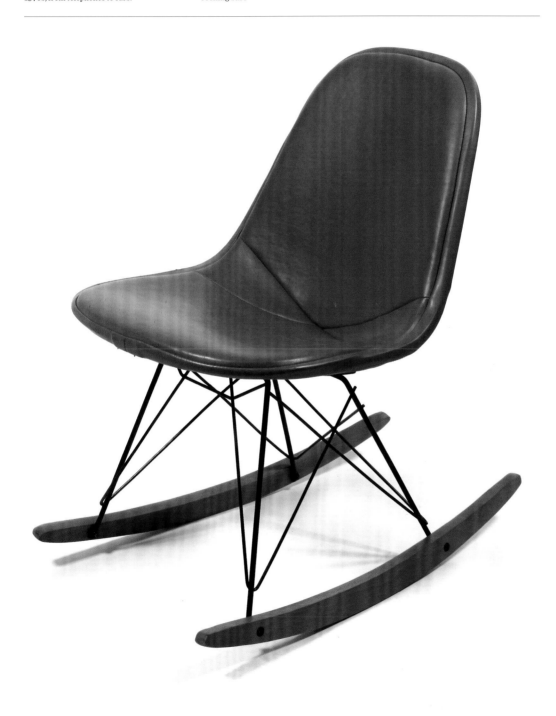

1					
C	40	R	80	PMS	371
M	0	G	95		
Y	100	B	50		
K	60				

Palette Variations

1

C	40	C	25	C	0	C	0	C	20
M	0	M	80	M	70	M	0	M	40
Y	100	Y	100	Y	100	Y	50	Y	100
K	60	K	15	K	0	K	0	K	0

2

C	45	C	30	C	0	C	0
M	20	M	0	M	10	M	0
Y	100	Y	0	Y	100	Y	0
K	0	K	0	K	0	K	25

3

C	30	C	0	C	0	C	0	C	0
M	0	M	0	M	0	M	0	M	0
Y	100	Y	0	Y	0	Y	0	Y	0
K	60	K	25	K	50	K	75	K	100

4

C	50	C	25	C	15
M	40	M	0	M	0
Y	100	Y	100	Y	100
K	10	K	25	K	0

5

C	0	C	0	C	0	C	90	C	100
M	0	M	0	M	60	M	100	M	70
Y	100	Y	100	Y	100	Y	15	Y	0
K	80	K	50	K	45	K	0	K	0

128

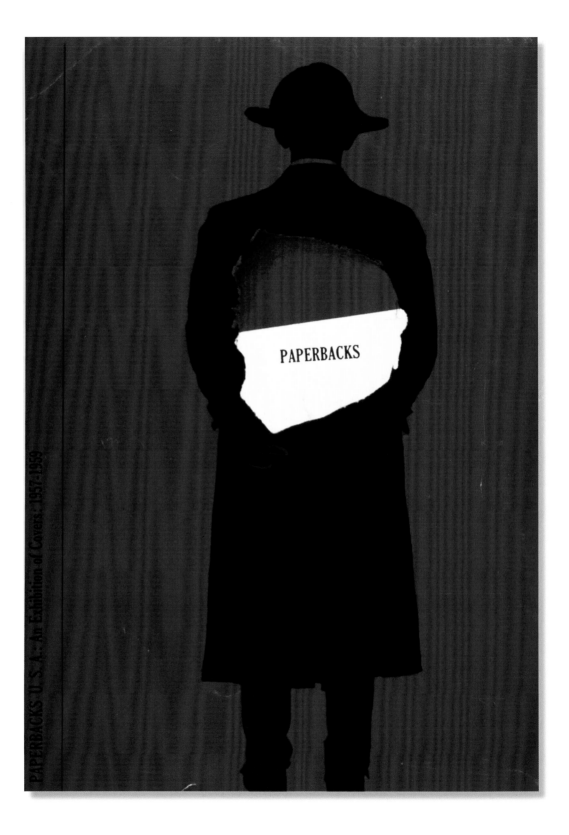

PAPERBACKS·U·S·A.: An Exhibition of Covers: 1957-1959

Blue

Blue \\'blü
From Middle English, from Old French *bleu*, ultimately of Germanic origin and related to Old English *blwen* ("blue") and Old Norse *blár* ("dark blue")

If asked, most clients will suggest blue for a logo color. It communicates honesty and loyalty. Blue is associated with the sky and water, power and authority. For decades, financial institutions and corporations insisted on blue as a corporate color due to its connection to stability and strength. It is the color on many flags and conveys patriotism. Blue is also the color of the Democratic Party in the United States, representing liberalism.

Blue can feel rich and hypnotic, or it can become banal and invisible, depending on the application. The term "type and blue stripe" is a reference to dull corporate graphics standards that utilized a bar of navy blue on the top or side of a page and white typography set in Helvetica. Alternatively, blue can be surprising when used dramatically and unexpectedly.

CULTURAL MEANINGS
In Western culture, blue is masculine, whereas pink is feminine. Aristocracy is referred to as blue-blooded. However, manual laborers are called blue-collar workers while professionals are white-collar workers. Blue is the color of holiness in Judaism. In Hinduism, blue represents the god Krishna.

SUCCESSFUL APPLICATIONS
GE logo
Wolff Olins, 2014

IBM logo
Paul Rand, 1972

Facebook logo
Cuban Council, 2005

OTHER NAMES
Cobalt
Navy
Indigo
Oxford Blue
Royal Blue

OPPOSITE
AIGA Paperbacks
Henry Wolf ~ 1957
Exhibition invitation
For an exhibition of paperback book covers, Wolf creates exactly that, a paperback. The typography references the spine of a book. The solid blue contrasts with the white form containing the headline.

The Graphic Work of Lester Beall
Lester Beall ~ 1962
Invitation
The halftone pattern of Lester Beall's face
interacts with the die-cut holes forming the
"LB" letterforms. The solid blue color is the
paper's color, not printed.

Blossa Tea
Scandinavian Design Group ~ 2016
Packaging
Influenced by the Swedish Christmas
tradition of mulled wine, the design of Blossa
15 reinvents illustration techniques from
traditional china by including the white and
blue of Chinese pottery.

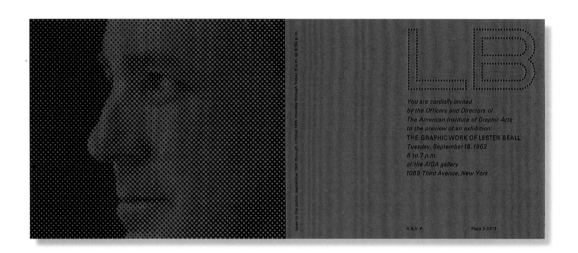

Cape Cod Evening
Edward Hopper ~ 1939
Painting
Hopper uses shades of blue on the trees and house, reinforcing a sense of isolation and cold. The chill is clear with the interaction of the two characters' silence and the dog's attention elsewhere.

Jadą Goście Jadą
Jan Lenica ~ 1963
Poster
Lenica preferred to use two-dimensional forms. Here he works with a monochromatic palette of blues—blue being a recessive color—to create space in his posters with neither background nor perspective.

Pan Am entered the jet age with a new logo,
a hemispheric globe overlaid with curved
parabolic lines to give an impression of an
airline without geographic demarcations.

Doyle uses a soccer ball, tennis ball, whiffle
ball, and other balls on a royal-blue back-
ground to create the solar system, part of
a promotion using maps and patterns.

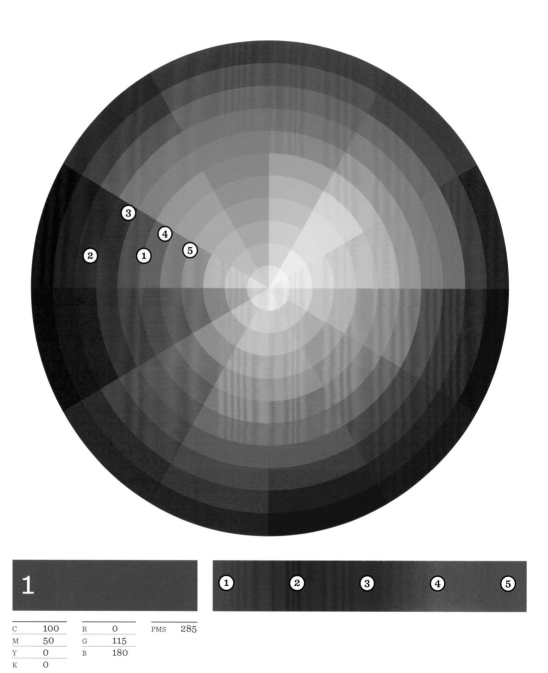

1					
C	100	R	0	PMS	285
M	50	G	115		
Y	0	B	180		
K	0				

Palette Variations

1

C	100	C	0	C	25	C	90	C	100
M	50	M	0	M	80	M	100	M	70
Y	0	Y	100	Y	100	Y	15	Y	0
K	0	K	50	K	15	K	0	K	0

2

C	100	C	0	C	0	C	50
M	90	M	70	M	10	M	0
Y	0	Y	100	Y	100	Y	100
K	0	K	0	K	0	K	0

3

C	100	C	0	C	0	C	0	C	0
M	50	M	0	M	0	M	0	M	0
Y	0	Y	0	Y	0	Y	0	Y	0
K	30	K	25	K	50	K	75	K	100

4

C	50	C	0	C	0
M	0	M	10	M	25
Y	0	Y	100	Y	100
K	50	K	0	K	0

5

C	100	C	70	C	60	C	50	C	25
M	0	M	0	M	0	M	20	M	0
Y	0	Y	0	Y	40	Y	0	Y	0
K	30	K	0	K	0	K	0	K	0

Chartreuse

139

CHARTREUSE

Chartreuse \shär-'trüz
From *La Grande Chartreuse*, the
Carthusian monastery near Grenoble,
where the liqueur was first made

Chartreuse is a color between green and yellow. Its name comes from the similarity to the color of the French liqueur, green chartreuse. It is a bold color verging on neon. Chartreuse is often used as a substitute for yellow, when a more aggressive tone is needed. It communicates boldness, youth, vitality, and creativity. Unlike mid-range green and its connection to nature, chartreuse is less restful.

For people who prefer yellow greens, chartreuse will work. But if a client likes green tones with more blue, it will never be accepted. Chartreuse as a name has a bad reputation. It is often referred to as a "fake" color, like aubergine, named by tricky marketing committees.

CULTURAL MEANINGS
A chartreuse aura suggests confidence, prosperity, travel, and growth. Negative connotations are sickness, disease, jealousy, and envy.

SUCCESSFUL APPLICATIONS
BP logo
Landor, 2000

Android identity
Irina Blok, Google, 2007

1972 Munich Olympics
Otl Aicher, 1972

OTHER NAMES
Absinthe
Citron
Lime
Spring Green
Yellow-Green

OPPOSITE
Wim Crouwel Exhibition
Cartlidge Levene ~ 2015
Poster
The format and grid used in many of Crouwel's posters for the Stedelijk Museum inspired this poster (one of seven) commissioned by Unit Editions to celebrate *Wim Crouwel: A Graphic Odyssey*—an exhibition at the Design Museum.

BELOW

Green Wheat Fields, Auvers
Vincent van Gogh ~ 1890
Painting

Painted just weeks before the artist ended
his life, *Green Wheat Fields, Auvers* provides
the viewer little to read in the composition.
The focus is on the color and brushwork.

OPPOSITE

Paul Rand: American Modernist
Jessica Helfand ~ 1998
Book cover

Helfand uses Rand's love of stripes, from the
IBM logo to *Apparel Arts* magazine, but adds
a twist—the bright yellow and chartreuse—
creating a reference to, not a reproduction
of, Rand.

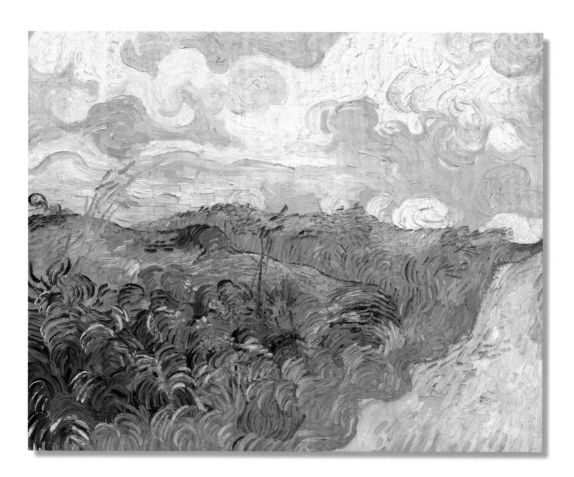

PAUL RAND:

American Modernist

Two Essays by Jessica Helfand

BELOW

USC Vertibi
Friend of a Friend ~ 2015
Magazine cover
USC Vertibi School of Engineering com-
missioned Friend of a Friend to move their
magazine into a more dynamic and energetic
place. The pure colors and fresh typography
reinforce this goal.

OPPOSITE

Chansons de Printemps
Louis Comfort Tiffany ~ 1989
Stained glass window
Tiffany invented new techniques to "paint"
on glass, redefining how stained glass
had been created since the 13th century.
The result was a luminous intensity of
color and form.

142

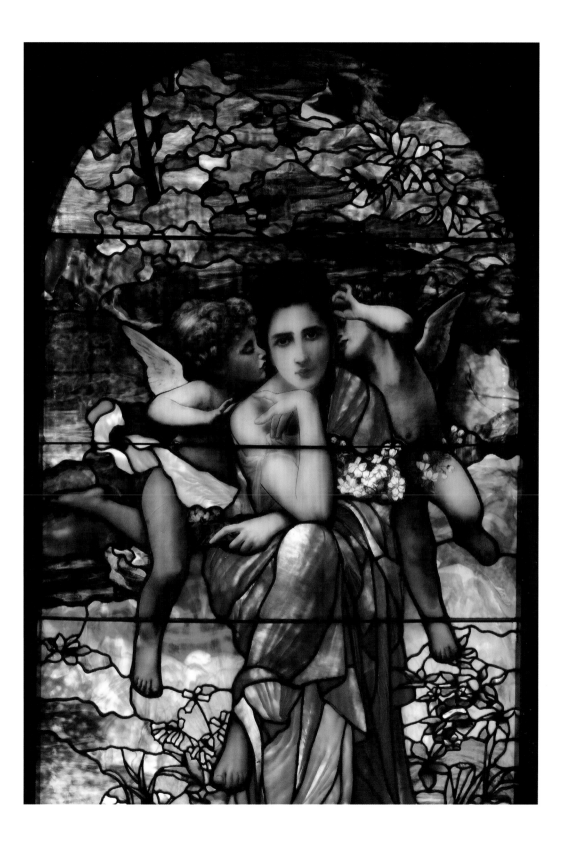

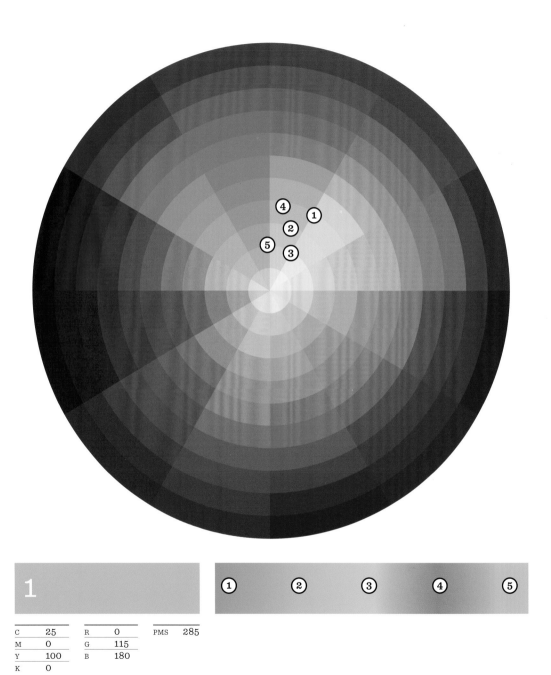

1				
C	25	R	0	PMS 285
M	0	G	115	
Y	100	B	180	
K	0			

Palette Variations

1

C	50	C	25	C	50	C	30
M	0	M	15	M	40	M	0
Y	100	Y	60	Y	100	Y	70
K	0	K	0	K	10	K	0

2

C	25	C	70	C	60	C	50	C	25
M	0	M	0	M	0	M	20	M	0
Y	100	Y	0	Y	40	Y	0	Y	0
K	0	K	0	K	0	K	0	K	0

3

C	15	C	0	C	0	C	0
M	0	M	0	M	0	M	0
Y	100	Y	0	Y	0	Y	0
K	0	K	25	K	50	K	75

4

C	25	C	10	C	0	C	0	C	20
M	0	M	0	M	10	M	25	M	40
Y	100	Y	80	Y	100	Y	100	Y	100
K	25	K	0	K	0	K	0	K	0

5

C	30	C	70	C	60	C	0	C	0
M	0	M	0	M	0	M	0	M	100
Y	70	Y	0	Y	40	Y	100	Y	0
K	0	K	0	K	0	K	0	K	0

S

SW

×

146

Green

Green \\\'grēn
From Old English *grēne* (adjective),
grēnian (verb), of Germanic origin,
related to Dutch *groen*, German *grün*,
also to "grass" and "grow"

Blue and yellow combine to create green. The most common tone has equal parts of blue and yellow. It communicates nature and the environment. It is also the color of money, regardless of a country's own currency design. Green can also communicate illness or decay. Historically, it was avoided on food packaging, but this practice has evolved with the onset of the organic and green movement.

Green can be used as a design element to calm warm colors, such as orange or red. This, however, needs to be monitored, as the right tone of each will create an optical vibration. Green is also a good complement to pink, suggesting ease and a casual lifestyle. It is closely related to Ireland and the color to symbolize Saint Patrick's Day.

CULTURAL MEANINGS
In Western culture, green is considered lucky, as in "the luck of the Irish." Green is the color used to say "go" in traffic lights. It is associated with envy and anger. Eastern cultures use green to convey fertility and regeneration.

SUCCESSFUL APPLICATIONS
Starbucks logo
Lippincott, 2011

Electric Wonders poster
John van Hamersveld, 1968

S&H Green Stamps
Andy Warhol, 1965

OTHER NAMES
Apple Green
British Racing Green
Emerald
Grass
Pistachio

OPPOSITE
Spotify
Collins ~ 2014
Poster
With clear and energetic colors, Collins redefined Spotify, an online music service, with emotion. The brand identity system is the visual corollary to the "bursting" experience felt when listening to music.

Brian H. Kim
Friend of a Friend ~ 2012
Website
Brian H. Kim is a composer for film, television, and multimedia. Friend of a Friend designed a web experience that unifies the multiple projects with a system of solid color over black and white images.

Rosemary's Baby
Gips & Danne ~ 1967
Poster
Rosemary's Baby is a film about a pregnant woman who gradually discovers that the true father of her baby is the Devil. Rather than pink or blue, green here symbolizes the unnatural and evil.

WCAU Radio Philadelphia
John Alcorn ~ 1959
Advertisement series
Alcorn combined a passion for craft and
appreciation of the handmade with vibrant
color at a time when high modernism
demanded corporate Helvetica and black
and white photography.

THEY BITE MORE OF OUR LISTENERS…

More different families listen daily and weekly to WCAU than to any other station in town.* So if you sell insecticides, choose the station that most effectively sprays the entire Pennsylvania vacation area. Remember, when Philadelphians head for the Poconos, they never go alone. WCAU's 18 top local personalities go along. Whatever you sell —soup, soap or silk stockings— don't get stung with a large summer inventory. Get the biggest bite of the market with WCAU.

*LATEST CUMULATIVE PULSE ANALYSIS.

WCAU RADIO PHILADELPHIA
Represented by CBS Radio Spot Sales

WCAU WILL NET YOU MORE FISHERMEN…

Because more different families listen daily and weekly to WCAU than to any other station in Philadelphia.* Look what we have for bait: 18 of the most persuasive personalities anywhere in radio. Whether you sell fishing tackle, clothes, beer, cigarettes or gas, WCAU reels in your customers. It figures: wherever Philadelphians go, more of them take WCAU along. Want to lure customers all the way from the Poconos to Delaware Bay this summer? Use the power line … WCAU Radio.

*LATEST CUMULATIVE PULSE ANALYSIS.

WCAU RADIO PHILADELPHIA
Represented by CBS Radio Spot Sales

Teknion
Vanderbyl Design ~ 2009
Branding
Teknion's commitment to sustainable
business practices encompasses the design,
development, and manufacturing of all its
products. Michael Vanderbyl reinforces this
message with green and living plants.

Interessante
Jessica Hische ~ 2014
Label
Hische explains that she wanted to create
a look that was "as interesting as the wine,"
using a green and gold foil palette that
complemented the color of the white wine.

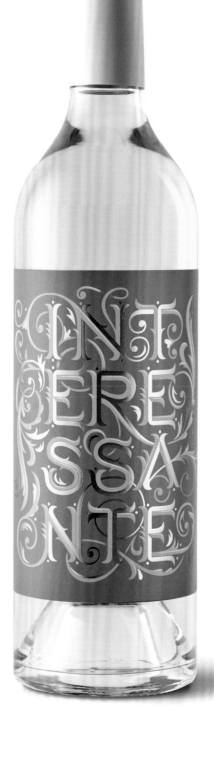

1					
C	100	R	0	PMS	354
M	0	G	160		
Y	100	B	180		
K	0				

Palette Variations

1

C	100		C	60		C	20		C	25
M	0		M	0		M	0		M	0
Y	100		Y	40		Y	20		Y	0
K	0		K	0		K	0		K	0

2

C	70		C	20		C	0		C	0		C	70
M	0		M	100		M	70		M	10		M	0
Y	100		Y	0		Y	100		Y	100		Y	10
K	0		K	0		K	0		K	0		K	0

3

C	100		C	0		C	0		C	0		C	0
M	20		M	0		M	0		M	0		M	0
Y	100		Y	0		Y	0		Y	0		Y	0
K	0		K	25		K	50		K	75		K	100

4

C	50		C	0		C	0
M	20		M	10		M	0
Y	100		Y	100		Y	10
K	0		K	0		K	0

5

C	100		C	30		C	25		C	20		C	20
M	0		M	95		M	65		M	40		M	20
Y	100		Y	100		Y	100		Y	100		Y	20
K	50		K	35		K	10		K	0		K	0

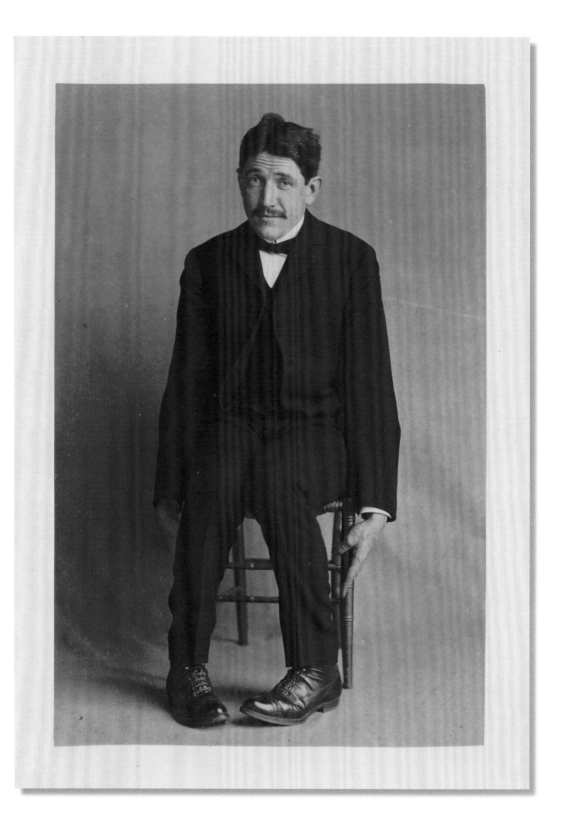

Light Blue

Light Blue
From Old English *leht*, earlier *leoht*, (daylight, not dark), Old High German *lioht*, Old Frisian *liacht*; from Old French *bleu*, ultimately of Germanic origin and related to Old English *blwen* "blue"

Blue is the color of power. It can communicate mature military authority on one end of the spectrum, and juvenile innocence on the other. Light blue is connected to a sunny sky. It communicates ideas of peace and quiet, the spiritual and infinite. Like yellow, light blue is a good substitute for gray if the designer desires a more colorful solution.

Light blue is not cyan. Cyan is more intense and acidic. On the screen, cyan will appear fluorescent, while light blue remains consistent with the printed version. Light blue with too much yellow becomes mint green. With too much red, it appears lavender. A true light blue is calming and reassuring.

CULTURAL MEANINGS
Light blue is connected to newborn baby boys in the West. White and light blue are the colors of Israel and are used for Chanukah decorations. The United Nations flag employs light blue to represent peace and serenity. Light blue is the color associated with the fifth (throat) chakra, relating to communication and self-expression.

SUCCESSFUL APPLICATIONS
Palais de Glace poster
Jules Chéret, 1894

Twitter logo
Doug Bowman, 2012

Windows 8 logo
Paula Scher, 2012

OTHER NAMES
Baby Blue
Columbia Blue
Cornflower
Sapphire
Sky Blue

OPPOSITE
Unidentified Man
Frances Benjamin Johnston ~ 1890
Cyanotype photograph
Sir John Herschel discovered the cyanotype procedure in 1842. It was originally intended purely for blueprints, but 19th- and 20th-century photographers explored its potential noncommercial uses.

OPPOSITE
Lace pattern with flowers
Larkin Goldsmith Mead ~ 19th century
Greeting card (detail)
From an album of ephemera and Civil
War–era photographs compiled by Larkin
Goldsmith Mead, this piece may be part of
a greeting card. Victorian imagery often
focused on innocence and purity.

BELOW
SF Toile
Mende Design ~ 2015
Shirt
Instead of depicting the pleasures of
18th-century pastoral England or France,
Mende's SF Toile shows the
hazards awaiting the unsuspecting
San Francisco cyclists.

159

For a series of lectures on diversity at MIT, Adams's poster focuses on the biological process of variation represented by a tree with many types of fruits. The shapes are created with circles, while the color palette is minimal and simple.

Boijmans van Beuningen is an art museum in the Netherlands. The new identity has a formal and an experimental side. The identity creates a lyrical three-line typeface. The graphics form strings of colored lines that interact visually with the art shown.

museum van
boijmans beuningen

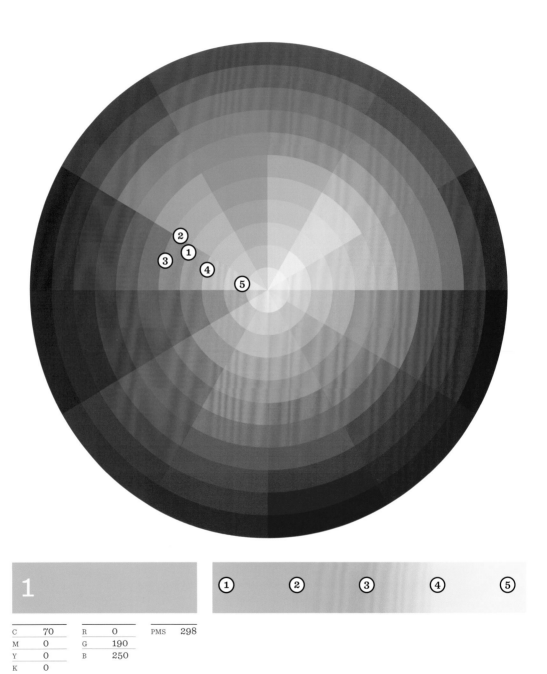

1				

C	70	R	0	PMS	298
M	0	G	190		
Y	0	B	250		
K	0				

Palette Variations

1

C 70	C 60	C 45	C 50	C 0
M 0	M 0	M 20	M 0	M 0
Y 0	Y 40	Y 100	Y 100	Y 100
K 0	K 0	K 0	K 0	K 0

2

C 70	C 0	C 0	C 0	C 0
M 0	M 65	M 70	M 10	M 0
Y 10	Y 25	Y 100	Y 100	Y 0
K 0	K 0	K 0	K 10	K 25

3

C 50	C 0	C 0	C 0	C 0
M 20	M 0	M 0	M 0	M 0
Y 0	Y 0	Y 0	Y 0	Y 0
K 0	K 25	K 50	K 75	K 100

4

C 30	C 0	C 0
M 0	M 0	M 0
Y 0	Y 100	Y 10
K 0	K 0	K 0

5

C 20	C 10	C 0	C 0	C 0
M 5	M 0	M 10	M 20	M 0
Y 0	Y 50	Y 100	Y 50	Y 0
K 0	K 0	K 0	K 0	K 25

Mint

Mint \\\'*mint*\\
From Old English *minte*, related to
German *Minze*, ultimately via Latin
from Greek *minthē*

Mint exists between light blue and light green. Mint is the younger sibling of green. It communicates growth, life, and the natural world. But it also conveys spring, youth, and beginnings. It is an especially pure color, maintaining a crisp and cool appearance. Mint is also delicate. It must be watched closely on press as it can shift to light blue or turquoise with too much or too little yellow. Due to the color differences on all monitors, mint will rarely display exactly as intended.

Mint can be used as an alternative to gray. It is light and works well as a neutral tone. The upside of mint is the cool and clean flavor, as if it were toothpaste. The downside is a chilly and clinical tone. Mint grew in popularity after World War II. Its synthetic and pure appearance was a counterpoint to the muted and dull colors of the 1930s and 1940s.

CULTURAL MEANINGS

Mint green is used in Western weddings to symbolize growth, financial prosperity, and innocence. A mint green candle is lit to achieve financial gain in New Age beliefs. In auras, mint green is seen with people involved in spiritual pursuits and advancement.

SUCCESSFUL APPLICATIONS
Bridge over a Pond of Water Lilies
Claude Monet, 1899

Bitter Pastore poster
Luigi Caldanzano, 1910

Crest toothpaste
Procter & Gamble, 1955

OTHER NAMES
Aquamarine
Caribbean Green
Celadon
Pale Green
Seafoam

OPPOSITE
Mid-Century Modern
Here Design - 2015
Book
Here Design took the phenomenal creative outpouring of mid-century modern design and unified it into a brand identity and holistic system for Thames & Hudson.

The Chevrolet Bel Air was a car in the mid-range of price, aimed at younger owners. The friendly pastel colors reflect the hopefulness of the 1950s, communicating the joy of freedom and travel.

Arquitectura Mexico magazine had a long history of working with some of the world's leading designers, including Herbert Bayer and Lance Wyman. The logo here incorporates the idea of three-dimensional structure.

BELOW
Boijmans van Beuningen
Thonik ~ 2015
Website

The wesbite for Boijmans van Beuningen incorporates the forms of the graphic system of colored lines that interact visually with the content. Like the identity (see page 161), the site has a formal and an experimental side.

PAGES 168–169
Waterloo Bridge, London, at Dusk
Claude Monet ~ 1904
Painting

Monet paints the natural world in the *plein-air* (open air) style, with a focus on light as a reaction to the industrial urbanization of late 19th- and early 20th-century Europe.

ONDERZEEBOOTLOODS ACHTERGROND/NIEUWS TENTOONSTELLING 2010 ROUTE/ARCHIEF/LINKS TOEGANGSBEWIJZEN

ONDERZEEBOOTLOODS WORDT EXPOSITIEHAL

Rotterdam herbergt vanaf mei de grootste tentoonstellingsruimte van Nederland. Havenbedrijf Rotterdam en Museum Boijmans Van Beuningen gaan samen de leegstaande Onderzeebootloods in de haven inrichten als tentoonstellingsruimte.

De eerste exposant is Atelier Van Lieshout, dat aan de overkant huist. De expositie in de loods neemt een kleine 5000 vierkante meter in beslag en duurt van eind mei tot en met het laatste weekend van september. Daarna wordt de loods iedere zomer heropend voor een nieuwe expositie van een nieuwe kunstenaar

AGENDA

YESTERDAY
Opening Notion Motion - Olafur Eliasson

20/04/2010
Laatste Weekend! Divided geopend tot einfd van de zomer

29/05/2010
Opening thematic exhibition by Atelier Van Lieshout

02/06/2010
Atelier van Lieshout ontvangt reddot design award

NEWSFEED

Museum Boijmans Van Beuningen verkent dit najaar de grenzen van de mode. Hedendaagse modeontwerpers begeven zich steeds vaker op het terrein van de beeldende kunst en beinvloeden op hun beurt de kunstwereld.

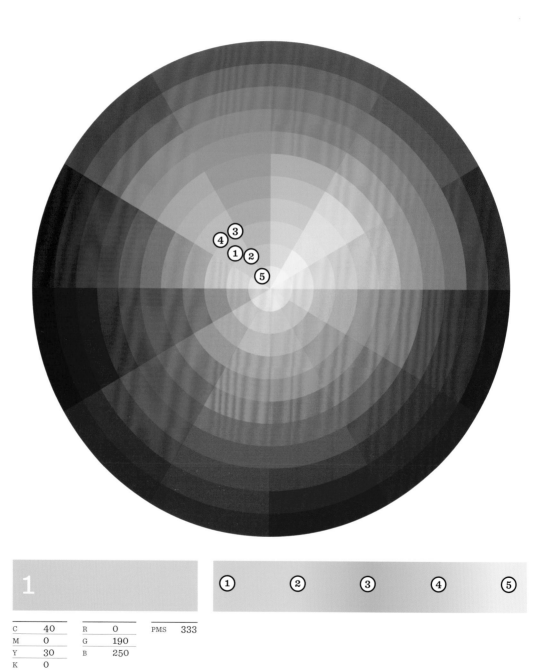

1				

C	40	R	0	PMS	333
M	0	G	190		
Y	30	B	250		
K	0				

Palette Variations

1

C	40	C	30	C	0
M	0	M	0	M	80
Y	30	Y	0	Y	60
K	0	K	0	K	0

2

C	30	C	60	C	70	C	40	C	50
M	0	M	0	M	0	M	0	M	20
Y	50	Y	40	Y	10	Y	40	Y	100
K	0	K	0	K	0	K	0	K	0

3

C	60	C	0	C	0	C	0	C	0
M	0	M	0	M	0	M	0	M	0
Y	40	Y	0	Y	0	Y	0	Y	0
K	0	K	25	K	50	K	75	K	100

4

C	40	C	0	C	15	C	0
M	0	M	0	M	15	M	0
Y	40	Y	100	Y	45	Y	0
K	0	K	50	K	0	K	50

5

C	20	C	10	C	0	C	25	C	0
M	0	M	0	M	20	M	0	M	50
Y	20	Y	80	Y	50	Y	0	Y	20
K	0	K	0	K	0	K	0	K	0

Olive

Olive \ˈä-liv
From Middle English, via Old French
from Latin *oliva*, from Greek *elaia*

Olive green is created from a combination of yellow and black. It is a softer version of avocado. Olive is a color loved by designers and hated by clients. It is complex and dense, changing with the light. It is the color of a perfectly ripe avocado, but is also the color of the vomit from *The Exorcist*. Designers should refer to the color as "olive," not "baby-shit green." Olive creates a somber and peaceful tone, as opposed to dark gray, which may read as funereal. In interior spaces, olive walls or furniture can be calming. It is also used to communicate environmental or "green" products.

Olive green is the traditional color of peace, derived from the olive branch and dove. At the same time, it is the color of the majority of military uniforms in the world due to its ability to blend in with an environment.

CULTURAL MEANINGS
In Buddhist culture, olive is a symbol of natural wisdom, intuition, and meditation. In Judaism, olive represents charity and the good of love:
Thou shalt plant vineyards and dress them, but thou shalt not drink of the wine; thou shalt have olive-trees throughout all thy border, but thou shalt not anoint thyself with the oil. (Deut. 28:39–40)

SUCCESSFUL APPLICATIONS
OG-107 United States Army uniform
United States Armed Forces, 1952

Matchbooks
Saul Bass, 1968

OTHER NAMES
Army Green
Camouflage
Drab
Khaki Green
Moss

OPPOSITE
U.S. Marine Corps
United States Armed Forces ~ c. 1941
Summer service uniform
The summer service uniform consists of green and khaki colors.
It is equivalent in function and composition to a business suit. The "khaki green" minimizes obvious stains and works as camouflage.

Range Rover Lincoln Green
Spen King ~ 1970
Car
Initially, Range Rovers had basic interiors
with vinyl seats and plastic dashboards that
were designed to be washed down with a hose.
Colors were chosen to accentuate the car as
an estate (or country) car.

Deer Hug
Office ~ 2012
Print
I Don't Believe in You Either is a Bigfoot-
inspired art exhibit benefiting 826 Valencia
and 826 Boston (home of the Bigfoot
Research Center).

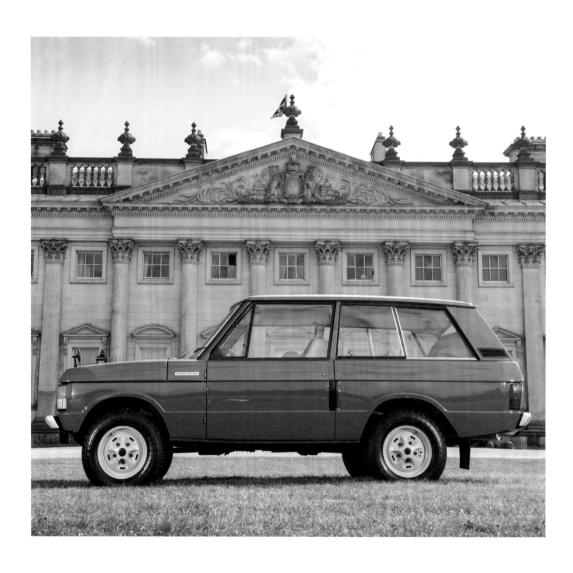

Marqués de Oliva
Lacía Branding & Packaging ~ 2016
Packaging

The Marqués de Oliva is a papal knighthood
granted by Leo XIII Apostolic. Lacía's
packaging for this extra-virgin olive oil
combines the leaf shape of an olive tree,
shades of olive, and classic typography.

De'Longhi Icona
De'Longhi ~ 2013
Kettle

The olive color for the De'Longhi kettle
combined with the product design is
reminiscent of Italian kettles of the 1950s.

176

1					
C	10	R	175	PMS	391
M	0	G	175		
Y	100	B	10		
K	30				

Palette Variations

1

C	10	C	30	C	15	C	15	C	10
M	0	M	0	M	30	M	15	M	0
Y	100	Y	100	Y	100	Y	45	Y	50
K	30	K	60	K	0	K	0	K	0

2

C	30	C	0	C	40
M	20	M	0	M	60
Y	100	Y	20	Y	100
K	0	K	75	K	30

3

C	0	C	0	C	0	C	0	C	0
M	0	M	0	M	0	M	0	M	0
Y	100	Y	0	Y	0	Y	0	Y	0
K	60	K	25	K	50	K	75	K	100

4

C	40	C	60	C	0	C	0
M	25	M	0	M	65	M	70
Y	100	Y	40	Y	25	Y	100
K	0	K	0	K	0	K	0

5

C	25	C	15	C	10	C	15
M	15	M	15	M	10	M	30
Y	60	Y	45	Y	20	Y	30
K	0	K	0	K	0	K	0

ATTENTION TO DETAIL IS AN ESSENTIAL OF FINE PRINTING

AT THE KRAFT PRINTING COMPANY 333 S. BROAD STREET PHILADELPHIA 7 KINGSLEY 5-3308

designed for the kraft printing company by don madden

Turquoise

Turquoise \\\tər-,kȯiz\\
From Middle English *turkeys*, from
Anglo-French *turkeise*, from feminine
of *turkeis* ("Turkish"), from *Turc*
("Turkish")

Turquoise is more vibrant and closer to blue than mint. Its brightness creates a happy tone, similar to yellow. Due to its popularity on 1950s' cars and appliances, turquoise can feel retro and nostalgic. It has a calming influence on coral, pink, and orange.

Turquoise is the color of communication, self-awareness, and initiative. Turquoise is used for healing and maintaining emotional stability in many cultures. It is soothing and connects with the blue-green of tropical seas. This in-between color represents water, thus the names aqua and aquamarine, other terms used for turquoise.

CULTURAL MEANINGS
Turquoise is closely associated with the Middle East and the American Southwest. It is a holy color in Islam and a spiritual stone of protection in Native American culture. Turquoise is one of the oldest protection amulets and in many ancient cultures was a symbol of wealth and prosperity. Due to its position between blue and green, it is a symbol of the development of wisdom and the cycle of life and death in Tibetan culture.

SUCCESSFUL APPLICATIONS
Kitchen appliances
1950–1966

Undercurrent album cover
Reid Miles, 1955

"Tiffany Blue" brand color
Charles Lewis Tiffany, 1845

OTHER NAMES
Aqua
Blue-Green
Robin's Egg Blue
Tiffany Blue
Verdigris

OPPOSITE
Attention to Detail
Don Madden - 1962
Advertisement
To highlight the refined printing quality at Kraft Printing, Madden incorporates small detailed lines, a solid yellow background, an over-printing of turquoise, and fine turquoise elements.

BELOW

When Hearts Are Trumps
Will Bradley ~ 1894
Book cover

Bradley, part of the Arts and Crafts Move-
ment, combines turquoise with orange for the
book cover of love poems. The image shows
the god of the wild, Pan, with a beautiful
nymph, Syrinx.

OPPOSITE

Burning Settlers Cabin
Sean Adams ~ 2014
Poster

For the launch of a new studio, Adams ties
together elements of the American Westward
Expansion, Mark Twain, a riverboat narra-
tive, and Western turquoise.

182

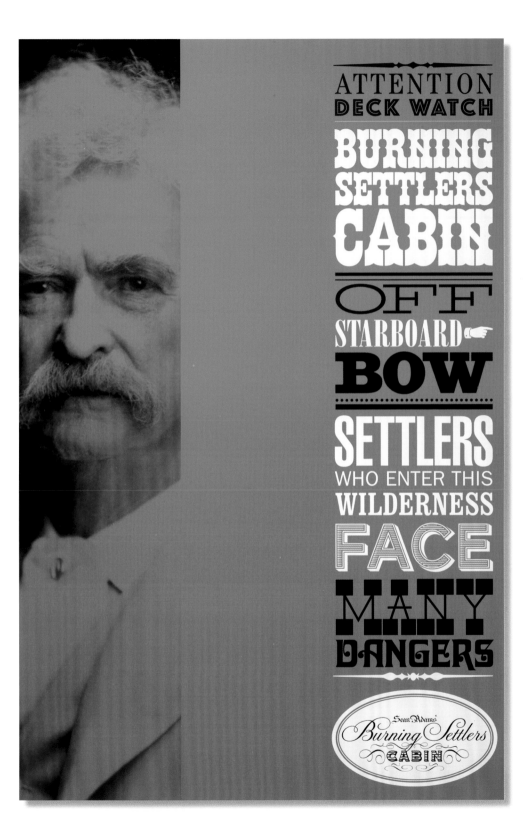

Enamel Tile, Tomb of Hafez
André Godard ~ 1935
Tile

This enameled-tile mosaic on the ceiling
of the pavilion at the Tomb of Hafez in Iran
incorporates traditional forms of Muslim
architectural details: geometric tile patterns
and rich colors such as turquoise and purple.

Sesame
Here Design ~ 2013
Branding

Offering authentic food in an unpretentious
space, Yotam Ottolenghi's restaurant
Sesame evokes the casual food stands
of the Middle East.

C	60	R	0	PMS	3125
M	0	G	180		
Y	20	B	205		
K	0				

Palette Variations

1

C	60	C	0	C	25	C	90	C	100
M	0	M	0	M	80	M	100	M	70
Y	20	Y	100	Y	100	Y	15	Y	0
K	0	K	50	K	15	K	0	K	0

2

C	50	C	0	C	0
M	0	M	100	M	10
Y	40	Y	0	Y	100
K	0	K	0	K	0

3

C	80	C	0	C	0	C	0
M	0	M	0	M	0	M	0
Y	40	Y	0	Y	0	Y	0
K	0	K	25	K	50	K	100

4

C	30	C	0	C	10	C	0	C	25
M	0	M	20	M	0	M	50	M	0
Y	20	Y	50	Y	50	Y	20	Y	0
K	0	K	0	K	0	K	0	K	0

5

C	60	C	10	C	0	C	0
M	0	M	0	M	10	M	25
Y	10	Y	80	Y	100	Y	100
K	0	K	0	K	0	K	0

Neutral Colors

BEIGE
190

BLACK
198

BROWN
208

GRAY

216

WHITE

226

Beige

Beige \\'bāzh\\
From mid-19th century French

Beige is a neutral color, darker than cream and lighter than tan. It has a pleasant, calming effect. Beige can appear warm or cool, depending on what colors you pair it with. As a color for graphic design, beige is often recessive and quiet. Many designers prefer a brighter option to create stronger contrast. Beige is difficult to reproduce in process CMYK printing. Too much cyan, yellow, magenta, or black will shift the color dramatically. If used, beige should be a specific PMS spot color. It has the same issues with RGB screen-based media. The intended color of beige will be different on every screen.

CULTURAL MEANINGS

Beige is associated with sustainability due to its connection to earth tones. It is connected with the absence of dye, communicating the rustic and natural. In Western culture, beige is connected to conservative values. Beige khaki pants and a blue blazer or a woman's beige suit communicate the desire to conform and not stand out. The early Macintosh computers were beige to promote a casual, friendly, and comforting tone, as opposed to a technological black or silver.

SUCCESSFUL APPLICATIONS
Macintosh 128K computer
Hartmut Esslinger, 1984

Design Group invitation
Lou Danziger, 1958

Die Konstruktivisten poster
Jan Tschichold, 1937

OTHER NAMES
Tan
Sand
Putty
Bisque
Straw

OPPOSITE
Mark and Graham
Morla Design - 2012
Packaging
For the Williams-Sonoma's brand, Mark and Graham, Jennifer Morla designed a pure and restrained system. The bridal line continued this with Morla's modern sensibility, clean design, and love of type.

Design Guild
Louis Danziger - 1951
Invitation
As a master of communication filtered to its most necessary elements, Danziger strips away all needless graphic forms. He creates an enormous area of beige negative space that becomes a dynamic element.

Down on the Farm
Simona Szabados - 2016
Book
A book about rural life and immigration issues in the United States is divided in half. The top, bright white, portrays the myth. The bottom, beige newsprint, shows the reality.

DG MEETING ✳ 1/19/51 ✳ 8 PM ✳ 1261 1/2 S. LA BREA ✳ BRING A CHAIR

TRUFAS ARTESANAIS
COM BRIGADEIRO

COCADA, AO LEITE,
PACOCA E GANACHE

CHOCOLATE BY BRIGADERIA

150g

COPINHOS DE
CHOCOLATE NOIR
COM BRIGADEIRO

AO LEITE, NINHO,
COCADA E
MEIO AMARGO

CHOCOLATE BY BRIGADERIA

200g

TABLETE
DE
CHOCOLATE
AO LEITE
100g

CHOCOLATE BY BRIGADERIA

TABLETE
DE
CHOCOLATE
NOIR
100g

CHOCOLATE BY BRIGADERIA

TABLETE
DE
CHOCOLATE
BRANCO
100g

CHOCOLATE BY BRIGADERIA

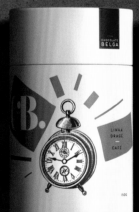

LINHA
DRAGÉ
—
CAFÉ

150G

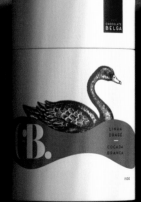

LINHA
DRAGÉ
—
COCADA
BRANCA

150G

LINHA
DRAGÉ
—
AMÊNDOAS

150G

LINHA DRAGÉ
AVELÃ

150G

CbyB chocolate
Casa Rex ~ 2016
Packaging
Set against a beige background, the bright
colors add vibrancy to the packaging. As
chocolate brown would recede on the shelf,
beige takes its place.

Bickford and Sons
Bickford's Australia ~ 2016
Packaging
The soft tan tones on the Bickford and Sons
packaging recalls Victorian-era handmade
products, communicating a dedication to
quality and high-end craft.

Color Range

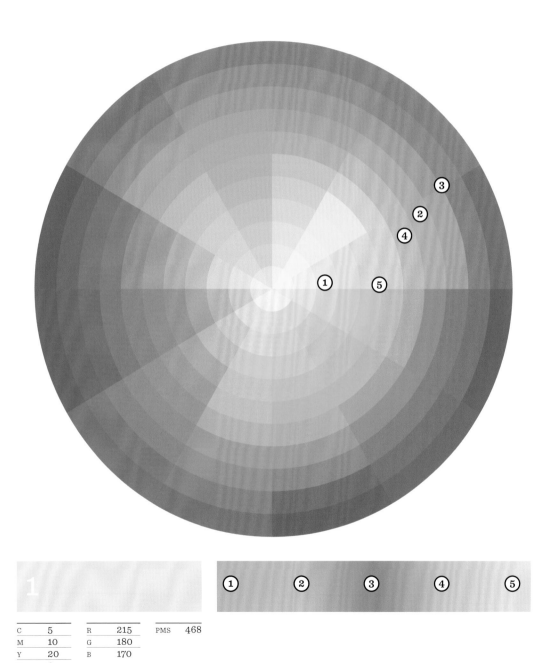

C	5	R	215	PMS	468
M	10	G	180		
Y	20	B	170		
K	0				

Palette Variations

1

C	5		C	25		C	0		C	0
M	10		M	15		M	0		M	0
Y	20		Y	60		Y	50		Y	0
K	0		K	0		K	0		K	5

2

C	20		C	0
M	20		M	0
Y	20		Y	50
K	0		K	0

3

C	15		C	0		C	0		C	0
M	20		M	0		M	0		M	0
Y	40		Y	0		Y	0		Y	0
K	10		K	25		K	75		K	100

4

C	15		C	20		C	10		C	0		C	0
M	15		M	40		M	80		M	60		M	0
Y	45		Y	100		Y	100		Y	100		Y	0
K	0		K	0		K	0		K	45		K	25

5

C	15		C	20		C	20		C	0		C	0
M	30		M	0		M	5		M	0		M	15
Y	30		Y	20		Y	0		Y	50		Y	0
K	0		K	0		K	0		K	0		K	0

CUT YOUR SHOWER SHORT DO THE GREEN THING

Black

Black \'blak
From the Old English *blæc*, Middle
English *blak*, related to Old High
German *blah* and to Latin *flagrare*
("to burn"), Greek *phlegein*

Black is technically not a color. It is the result of any color shifted to its darkest value. As an aesthetic tool, black will add gravity to any project. Too many bright colors together may create an overly saccharine tone. Adding black counteracts this "sweetness." Black is often the default color of text due to its legibility when printed or seen on white. The bold nature of black creates drama and confidence.

Black is sophisticated, formal, and sleek. As the color of a tuxedo or the "little black dress," it communicates a mature confidence. Too much black in the wrong context, however, may become funereal. As the primary color for a children's brand, black may read as depressing.

CULTURAL MEANINGS
Ancient Egyptians viewed black as a positive color. It was the color of Anubis, the god of the underworld who protected the dead from evil. The Romans first used black as a color of mourning. In medieval Western culture, black represented power and secrecy. It was the color worn by monks and clergy. Hindu traditions use black as the color of Kali, the goddess of time and change. In contemporary society, black represents death, the night, and mystery.

SUCCESSFUL APPLICATIONS
Saks Fifth Avenue identity
Michael Bierut, 2007

The National Theatre posters
Ken Briggs, 1960s

IBM Building
Mies van der Rohe, 1973

OTHER NAMES
Ebony
Midnight
Ink
Onyx
Jet Black

OPPOSITE
Water Conservation
Pentagram, Michael Bierut - 2013
Poster
From Alfred Hitchcock's film *Psycho*, Bierut uses the shower scene's deadly encounter to warn the viewer to use less water. The large black halftone dots create the dramatic black and white effect.

JAN TSCHICHOLD

DIE NEUE TYPOGRAPHIE

EIN HANDBUCH FÜR ZEITGEMÄSS SCHAFFENDE

BERLIN 1928
VERLAG DES BILDUNGSVERBANDES DER DEUTSCHEN BUCHDRUCKER

PAGES 200–201
Die Neue Typographie
Jan Tschichold ~ 1928
Book

To represent the idea that the white back-
ground of a page is a formal element,
Tschichold uses white negative space on
one page and black negative space on the
opposite page.

BELOW
Blow-Up
Unknown ~ 1967
Broadsheet

Michelangelo Antonioni explored themes
of isolation, the inability to communicate,
and the nature of reality. The one-sheet here
uses a solid black section of film to speak
to nothing.

OPPOSITE
Ellen Peabody Endicott
John Singer Sargent ~ 1901
Painting

Black is used in the subject's dress against
the dark background to highlight her pale
flesh tone and white shawl. Mrs. Endicott
wears a black mourning gown after the
loss of her husband.

BELOW
MIT Graduate Programs
Dietmar Winkler ~ 1967
Poster
Winkler focuses attention on the remarkable word combinations with a solid black background, small body copy, and active letterforms.

OPPOSITE
Aloha, Mr. Hand
Sean Adams ~ 2013
Skate-deck
The design of this skateboard deck takes dialogue from the film *Fast Times at Ridgemont High*. These quotes relate to the endlessly stoned Jeff Spicoli and hard-line teacher, Mr. Hand.

Aloha, Mr. Hand

➡ All I need are some tasty waves, a cool buzz, and I'm fine.
➡ Where'd you get this jacket? Stu: I got this from the network.
➡ What Jefferson was saying was, Hey! You know, We left this England place 'cause it was bogus; so if we don't get some cool rules ourselves, pronto, we'll just be bogus too! Get it?
– Jeff Spicoli
➡ What are you, people? On dope?
– Mr. Hand

1				

C	0	R	35	PMS
M	0	G	35	PROCESS
Y	0	B	35	BLACK
K	100			

Palette Variations

1

C 0	C 0
M 0	M 0
Y 0	Y 0
K 100	K 0

2

C 50	C 0	C 0	C 0
M 50	M 100	M 0	M 10
Y 50	Y 100	Y 0	Y 100
K 100	K 0	K 25	K 0

3

C 60	C 0	C 0	C 0	C 0
M 70	M 0	M 0	M 0	M 0
Y 50	Y 0	Y 0	Y 0	Y 0
K 70	K 25	K 50	K 75	K 100

4

C 35	C 0	C 0
M 0	M 90	M 0
Y 0	Y 100	Y 0
K 90	K 0	K 0

5

C 0	C 0	C 15	C 0
M 20	M 0	M 15	M 0
Y 85	Y 50	Y 45	Y 0
K 90	K 0	K 0	K 25

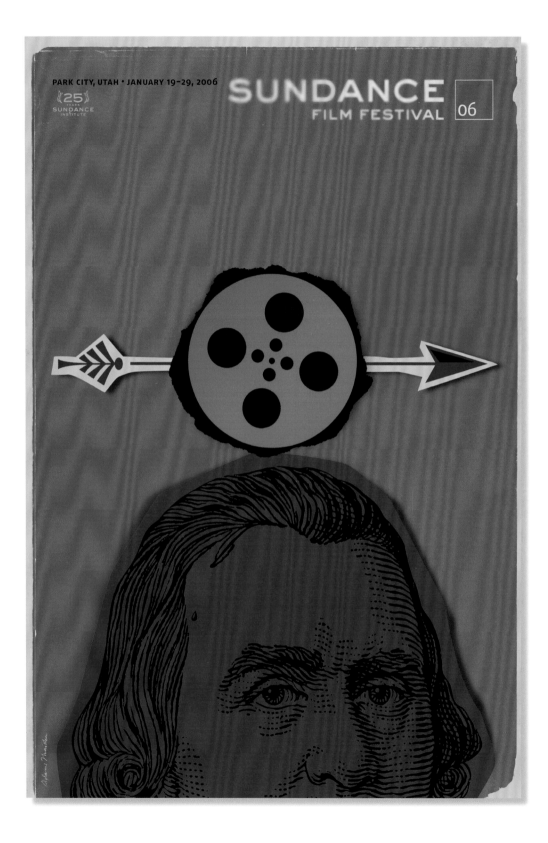

Brown

Brown \\'braủn
From Old English *brūn*, similar to Dutch *bruin*, German *braun*, Old Norse *brūnn*, related to Lithuanian *brúnas*

Brown is a complex color. It is a mix of other colors. A shade of brown can vary dramatically when pushed toward warm, cool, dark, or light tones. For a designer, this is the difference between a color that communicates an earthy, solid, sensual message, and one related to baby diapers.

When accompanied with green, brown reads a natural color. This combination is typically overused with branding related to "organic" and "sustainability." Brown and orange were popular colors in the 1970s, again communicating a return to the natural world and rejection of the synthetic. A palette of shades of brown, from tan to gray brown, can read as sophisticated and solid.

CULTURAL MEANINGS
Most cultures connect brown with the earth. It is wholesome and stable. In the United States, brown and orange are the colors of Thanksgiving. In India, brown is the color of mourning as it relates to dying leaves. The early Nazi party used brown uniforms, referred to as "brown-shirts."

SUCCESSFUL APPLICATIONS
UPS logo
Paul Rand, 1961; FutureBrand, 2003

Hershey's packaging
Hershey Chocolate Corporation , 1950

LV Damier bag
Louis Vuitton, 1888

OTHER NAMES
Coffee
Chocolate
Mocha
Hickory
Mahogany

OPPOSITE
Sundance Film Festival
Sean Adams, AdamsMorioka- 2006
Poster
The campaign for the 2006 festival pulled together multiple myths and stories, talking to the idea of narrative in film. The William Tell story alludes to precision, faith, and fear.

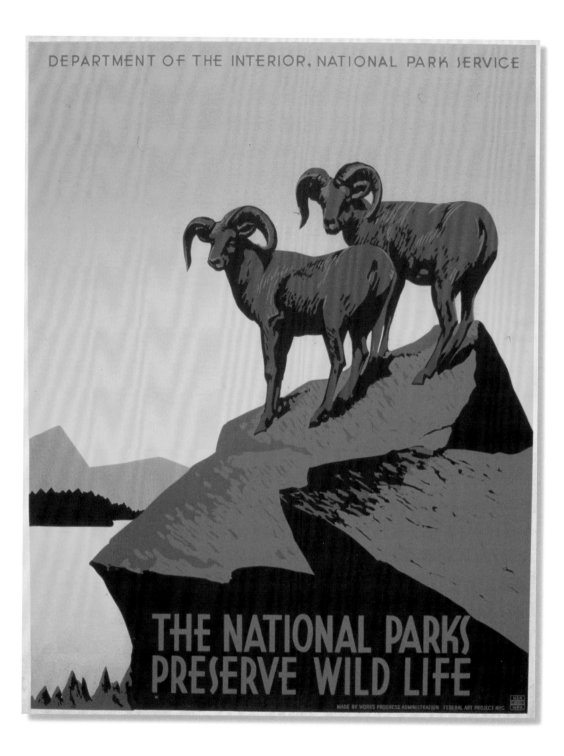

OPPOSITE
"The National Parks Preserve Wild Life"
J. Hirt ~ 1936
Poster
The Work Projects Administration (WPA) commissioned hundreds of posters during the Great Depression of the 1930s. This poster depicts two bighorn sheep at a national park in the western United States.

BELOW
Casseroles
Edith Heath ~ cs. 1950–2003
Casseroles, redwood glaze
Heath's products maintain a tradition of utility and beauty that is true to the materials. The glazing technique and production allow for natural colors and variation from one piece to another.

PAGES 210–211
Nature Benefits Us All
Volume Inc. ~ 2014
Exhibition
For the Boy Scouts of America's *Sustainability Treehouse* exhibition program, Volume uses nature's natural processes to translate these principles to everyday life.

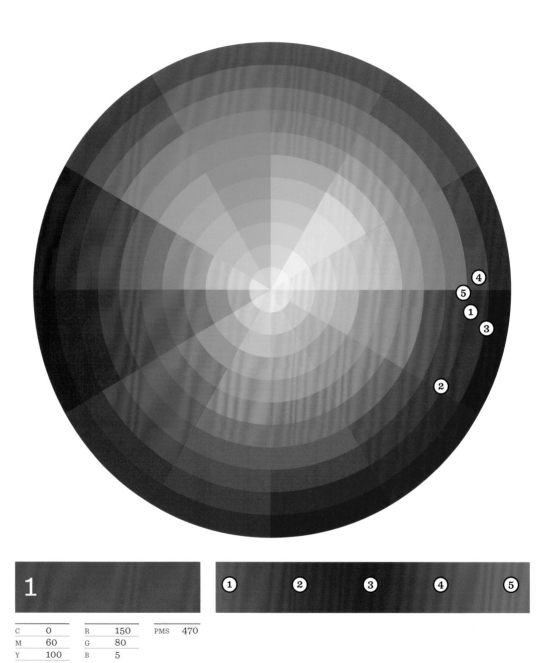

1					
C	0	R	150	PMS	470
M	60	G	80		
Y	100	B	5		
K	45				

Palette Variations

1

C	0	C	0	C	0	C	0	C	20
M	60	M	25	M	70	M	0	M	40
Y	100	Y	100	Y	100	Y	50	Y	100
K	45	K	0	K	0	K	0	K	0

2

C	30	C	0	C	0	C	0
M	95	M	10	M	0	M	0
Y	100	Y	100	Y	0	Y	0
K	35	K	0	K	25	K	5

3

C	30	C	0	C	0	C	0	C	0
M	80	M	0	M	0	M	0	M	0
Y	100	Y	0	Y	0	Y	0	Y	0
K	60	K	25	K	50	K	75	K	100

4

C	40	C	25	C	15	C	100
M	60	M	0	M	0	M	50
Y	100	Y	100	Y	100	Y	0
K	30	K	25	K	0	K	30

5

C	25	C	0	C	0	C	90	C	100
M	65	M	0	M	100	M	100	M	70
Y	100	Y	100	Y	100	Y	15	Y	0
K	15	K	50	K	50	K	0	K	0

Paolo Zellini A Brief History of Infinity

Gray

Gray \grā\
From Old English *grag*, related to Old
High German *grāo*, Dutch *grauw*,
Old Norse *grar*

Gray rests on a wide spectrum between black and white. It is recessive and can appear dull and emotionless. It is often used as a background tone due to its impartiality and neutrality. A dark charcoal gray may appear rich and sophisticated. A light gray reads as subtle and elegant. Medium gray, however, appears noncommittal and passive. Rather than resorting to a flat medium gray, many designers use another mid-range color such as a warm yellow, light blue, or pink.

Gray is mature and unrelated to juvenile communication. It is associated with gray hair, weapons, and an executive's business suit. Gray is used as a metaphor for conformity in Sloan Wilson's *The Man in the Gray Flannel Suit*. Charcoal gray can convey the same attributes as black while averting the associations of death and darkness.

CULTURAL MEANINGS
The term "gray area" is used as a way to describe issues that have no clear moral value. Franciscan friars wore gray as a symbol of their vow of poverty. The color of the Confederate Army during the American Civil War was gray, while the Union Army was blue.

SUCCESSFUL APPLICATIONS
Vertigo gray suit
Edith Head and Alfred Hitchcock, 1958

10:56:20 PM 7.20.69
Lou Dorfsman, 1969

Arrangement in Gray and Black No.1
James McNeill Whistler, 1871

OTHER NAMES
Charcoal
Smoke
Slate
Fog
Graphite

OPPOSITE
A Brief History of Infinity
David Pearson - 2004
Book cover
The smallest detail of light on a gray field is evocative of humanity's attempts to comprehend the concept of infinity.

Over five years, the Beatles transformed from clean-cut mods in gray collarless suits to bearded hippies wearing brightly colored paisley, striped, and floral patterns on their shirts.

Typically, designers avoid a "gray" page. Here, Lubalin embraces the gray page. He creates a broadside using the entire book of Genesis. The strict columns create a rhythm of gray and white stripes.

In the beginning God created the heaven and the earth.

genesis

Filmforum
Sean Adams - 2015
Poster
The view through the windshield on a freeway
is a common sight in Los Angeles. For an in-
dependent film series, Adams forgoes sunny,
bright Southern California for a journalistic
gray image.

Scope
Lester Beall - 1950
Magazine cover
Published by Upjohn Pharmaceuticals,
Beall's cover for *Scope* avoids the traditional
medical magazine imagery. Here, he
employs abstract geometric shapes against
a 19th-century engraving.

Wet Night, Columbus Circle, New York
William A. Fraser - 1899
Photograph

Fraser created this photograph, a symphony of gray tones, following the tenets of pictorialism. Pictorialist photographs were often soft, blurry, and manipulated by the photographer, much like an impressionist painting.

OPPOSITE

Exhibitor
Vanderbyl Design - 2005
Poster

Vanderbyl's poster for the annual Exhibitor conference plays with the nature of a flat two-dimensional design and three-dimensional elements. Gray neither advances nor recedes visually, adding to the ambiguity.

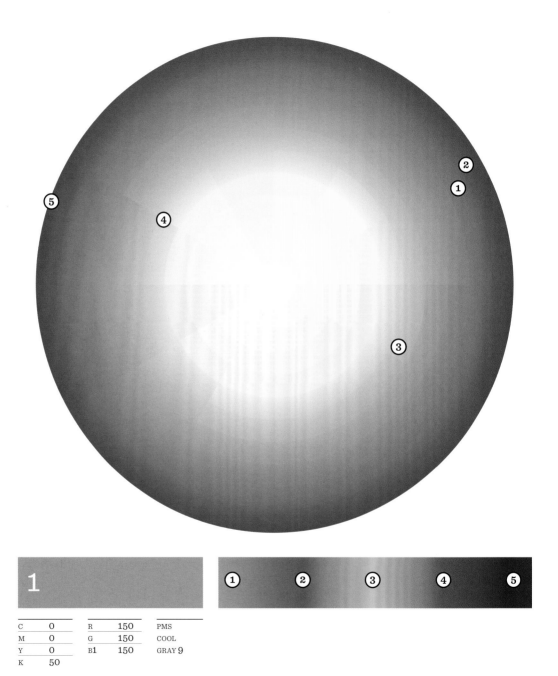

1					
C	0	R	150	PMS	
M	0	G	150	COOL	
Y	0	B1	150	GRAY 9	
K	50				

Palette Variations

1

C	0		C	0
M	0		M	0
Y	0		Y	0
K	50		K	0

2

C	0	C	0	C	0	C	0
M	0	M	100	M	0	M	10
Y	0	Y	100	Y	0	Y	100
K	75	K	0	K	25	K	0

3

C	20	C	0	C	0	C	0	C	0
M	20	M	0	M	0	M	0	M	0
Y	20	Y	0	Y	0	Y	0	Y	0
K	0	K	25	K	50	K	75	K	100

4

C	0	C	0	C	0
M	0	M	90	M	0
Y	20	Y	100	Y	0
K	75	K	0	K	0

5

C	0	C	0	C	15	C	0
M	0	M	0	M	15	M	0
Y	0	Y	50	Y	45	Y	0
K	90	K	0	K	0	K	25

White

White \\ˈhwīt
From before 900 CE, late Old English *hwīt*, Middle English *whit*, of Germanic origin, related to Dutch *wit* and German *weiss*, also to "wheat"

In design, the absence of forms on a page or screen is described as white space. This leads to the mistaken idea that white is boring or dull. White is rarely used as a dominant color. However, white is the contrasting color that creates drama when used with dark colors or black. It is a tool to create order and provide space for the viewer to digest information or a concept.

As a communication device, white stands out in a crowded visual environment. There are many variations of white, from off-white to cream white. The slightest addition of another color will shift the emotional temperature from cold to warm.

CULTURAL MEANINGS
Western culture views white as a symbol for purity, virginity, innocence, and cleanliness. In Asian cultures, white is the color of death and mourning. A white carnation symbolizes death in Japan, while a white rose is associated with marriage and new beginnings in Western culture. A white flag is a symbol of truce. Professionals are called white-collar workers, while a laborer is a blue-collar worker.

SUCCESSFUL APPLICATIONS
White Album
Richard Hamilton, 1968

Gastrotypographicalassemblage
Lou Dorfsman, Herb Lubalin, and
Tom Carnese, 1966

OTHER NAMES
Ivory
Snow
Pearl
Bone
Linen

OPPOSITE
The Pressery
Tim Jarvis ~ 2015
Branding
Branding for The Pressery was an exercise in rigorous minimalism, reflecting the pure values of this handmade product. No ingredients are used that aren't required. No design elements are used that aren't absolutely necessary.

Brockmann's business card emphasizes the white space as the dominant element. The typography, one size, one weight—all Akzidenz-Grotesk—only serves to punctuate the white negative space.

Created for Clorox Bleach's 100th anniversary, the book was designed to embody, quite literally, their iconic bottle. The vacuum-formed cover uses the same material as a Clorox bottle.

josef müller-brockmann

studio	4	enzianweg	privat	15	bergstrasse
	8048	zürich		8103	unterengstringen
	tel.	01 - 54 40 22		tel.	01 - 79 38 24
		switzerland			switzerland

Boylan Heritage Tonic
Boylan Bottling Co., W&P Design ~ 2016
Packaging
The Boylan Heritage line of cocktail mixers is
the result of a collaboration between Boylan
Bottling Co. and W&P Design. The reductive
design clarifies Boylan Heritage Tonic's crisp
and classic qualities.

Luna Textiles
Vanderbyl Design ~ 2012
Showroom
Vanderbyl's design for the Luna Textiles
showroom uses white as a backdrop for the
company's products. Crisp black elements
ground the design solution, preventing it from
becoming recessive.

1		①	②	③	④	⑤

C	0	R	255
M	0	G	255
Y	0	B1	255
K	0		

Palette Variations

1			
C	0	C	0
M	0	M	0
Y	0	Y	0
K	0	K	100

2							
C	0	C	20	C	0	C	0
M	5	M	0	M	0	M	0
Y	0	Y	20	Y	0	Y	50
K	0	K	0	K	25	K	0

3									
C	0	C	0	C	0	C	0	C	0
M	0	M	0	M	0	M	0	M	0
Y	10	Y	0	Y	0	Y	0	Y	0
K	0	K	25	K	50	K	75	K	100

4						
C	0	C	0	C	0	
M	0	M	80	M	0	
Y	0	Y	100	Y	0	
K	5	K	0	K	100	

5						
C	5	C	15	C	0	
M	0	M	15	M	0	
Y	0	Y	45	Y	0	
K	0	K	0	K	25	

Specialty Colors

FLUORESCENT

236

METALLIC

244

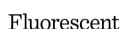

Fluorescent

Fluorescent \flu-ˈres-sənt
From 1852, modeled after the etymology of opalescence

Fluorescent colors use a larger amount of both the visible spectrum and the lower wavelengths compared to conventional colors. As a result, your eye perceives a far more intense color. A conventional color reflects a maximum of 90%; a fluorescent color can reflect as much as 300%.

A solid fluorescent color will add visual presence to a project. It is unapologetically confident and clear. To achieve the best result in offset printing, a double hit of the color is advised. Fluorescent magenta and yellow can be added to CMYK images as spot colors to add punch. On screen, fluorescent cyan, magenta, and yellow are aggressive, but may read as technical and cold.

CULTURAL MEANINGS
Fluorescent colors are most closely associated with the Fillmore posters of the 1960s and black-light rock posters of the 1970s. Both of these used fluorescents as a way to simulate a hallucinogenic experience. By the 1980s, fluorescent colors were adopted by teenage and juvenile audiences—this time, more closely aligned with optimism than drug use.

SUCCESSFUL APPLICATIONS
"Wake Me Up Before You Go Go"
Andy Morahan, George Michael, 1984

Silver Surfer comic books
Jack Kirby, c. 1970

Endless Summer poster
John Van Hamersveld, 1964

OTHER NAMES
Day-Glo
Neon
Techno
Hot
Electric

OPPOSITE
PLUNC
The Royal Studio ~ 2015
Poster
The identity for PLUNC, a multimedia arts festival in Lisbon, was designed with a set of parameters and solutions generated by code. This allows the final result to be chosen at random. There is an infinite number of solutions focusing on the representation of two elements: circles and brackets.

Earthquakes, Mudslides, Fires & Riots:
California & Graphic Design, 1936–1986
Louise Sandhaus Design ~ 2015
Book
This is the first publication to capture the enormous body of visually ecstatic graphic design that emanated from California throughout most of the 20th century.

Base Museum
Paola Meraz ~ 2015
Poster
For a rebrand exploration for San Francisco's Exploratorium, Meraz designed a strategy and system to change the way the audience learns. BASE is an acronym for Bridging Art and Science Education.

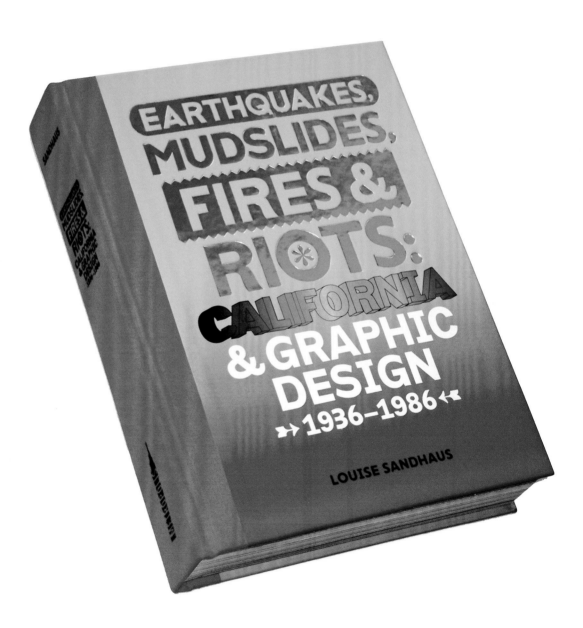

BASE

IMAGINATION IS THE BASE OF CREATION. CREATIVITY IS JUST PIECING THINGS TOGETHER

basemuseum.edu

find us: Pier 15 San Francisco

239

FLUORESCENT

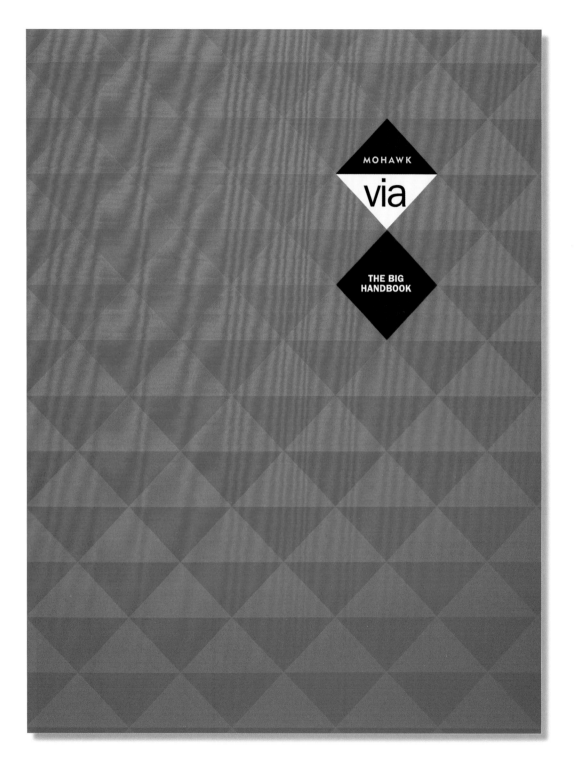

MOHAWK

via

THE BIG
HANDBOOK

OPPOSITE
Mohawk Via
Sean Adams, AdamsMorioka~ 2008
Book cover
This cover for Mohawk Via paper was
designed to demonstrate the printing quality
of the paper. The cover has a double hit of
fluorescent pink and overprint of process
yellow, creating the red triangles.

BELOW
Hill & Friends
Construct ~ 2015
Packaging
Hill & Friends is a luxury yet functional bag
brand with a subversive wink. Construct
designed a simple and elegant mark and used
fluorescent pink as an unexpected element.

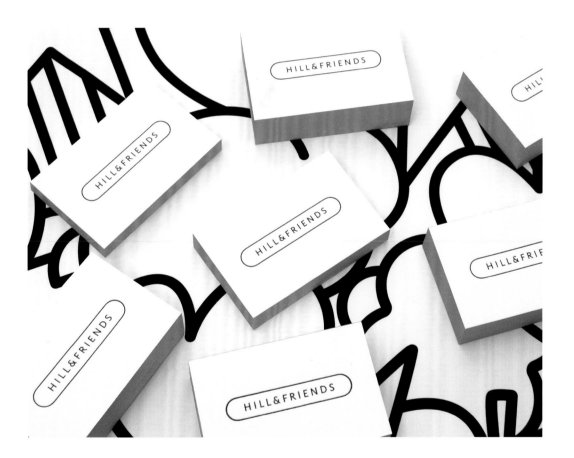

Color Range

CMYK only

CMYK + fluorescent
*To add intensity, fluorescent magenta
and yellow are added to the CMYK.*

1

R	255	PMS	803
G	233		
B	0		

2

R	255	PMS	806
G	63		
B	180		

*Note:
CMYK process color cannot
replicate fluorescent colors*

Palette Variations

1

R	255		C	0
G	233		M	0
B	0		Y	0
PMS	803		K	0

1

R	255		R	255		C	0
G	233		G	63		M	0
B	0		B	180		Y	0
PMS	803		PMS	806		K	100

1

R	255		C	0		C	0		C	0
G	233		M	0		M	0		M	0
B	0		Y	0		Y	0		Y	0
PMS	803		K	25		K	50		K	75

2

R	255		C	30		C	0		C	0		C	0
G	63		M	100		M	70		M	100		M	0
B	180		Y	0		Y	100		Y	100		Y	100
PMS	806		K	0		K	0		K	0		K	0

2

R	255		C	0
G	63		M	0
B	180		Y	50
PMS	806		K	0

Metallic

Metallic \mə-ˈta-lik
Late Middle English via Latin from
Greek *metallikos*, from *metallon*

The reflectivity of metallic ink depends on several factors: the surface material, varnish or lack of varnish, technique, and scale. Printing a spot color of gold on uncoated paper will appear brown. Printing the same color on a gloss-coated sheet with a gloss varnish will appear shiny and closer to the desired effect. To fully capture the highest level of shine, a foil is required. In the process, foil-stamping machines use heat to transfer a metallic foil to paper or another material.

Gold, silver, copper, or bronze in a design solution can add elegance and richness. The most common issue is a client requesting a metallic, such as gold, without being willing to pay for the expense of a foil. The result is a brown stamp on a letterhead or brochure.

CULTURAL MEANINGS
Metallic gold represents wealth and luxury across all cultures. In Western cultures, gold may also represent the sin of idolatry and avarice, as represented in biblical terms. In pagan beliefs, silver is the feminine equivalent of gold in the same way that the silver moon is feminine and the golden sun is masculine.

SUCCESSFUL APPLICATIONS
Goldfinger title sequence
Robert Brownjohn, 1963

Walt Disney Concert Hall
Frank Gehry, 2003

66th Annual Academy Awards poster
Saul Bass, 1994

OTHER NAMES
Gold:
Gilded
Halcyon
Silver:
Sterling
Chrome

OPPOSITE
The Shapes of Things to Come
ART+COM Studios - 2012
Kinetic Sculpture
At the BMW Museum, Munich, Germany, in a 65-square-foot (6-square-meter) field, 714 metal spheres are suspended from the ceiling on thin steel wires and animated with the help of mechanics, electronics, and code to create the shape of BMW cars.

Golden Meaning
GraphicDesign& - 2014
Book
Golden Meaning (think Fibonacci) collects
the responses of 55 designers, typographers,
and image-makers to communicate, explore,
or explain the golden mean. Shown here is the
contribution from Homework.

246

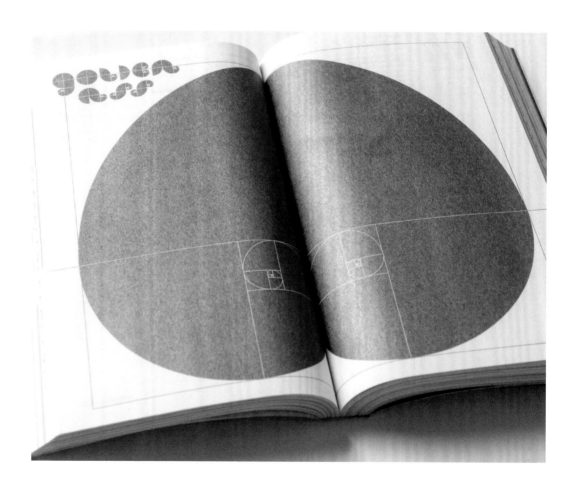

F. Scott Fitzgerald
Coralie Bickford Smith ~ 2010
Book covers
The elegance and glamour of the art deco
period, with the sense of ornate detail fused
with the modernist aesthetic of mechanical
repetition, is created with gold, copper, and
silver foil.

Mercedes-Benz SL-Class
Daimler AG ~ 1954–2008
Automobiles
The SL was the fastest production car of
its day. The car was the result of an idea of a
toned-down Grand Prix car tailored to afflu-
ent performance enthusiasts in the booming
postwar American market.

Sundance Film Festival 2005
Sean Adams, AdamsMorioka ~ 2004
Poster
The world's most influential film festival
is held each winter in Park City, Utah. The
limited-edition poster with gloss and matte
metallic silver refers to a cowboy's rodeo
award belt buckle.

2005 Sundance Film Festival

Park City, Utah • January 20–30, 2005

SUNDANCE

Platner Coffee Table
Knoll, Inc., Warren Platner ~ 1966
Coffee table
The table, reflecting Platner's brand of mod-
ernism, is made up of hundreds of individual
welds, all soldered by hand, resulting in forms
that recall golden sheaves of wheat.

BELOW
Initial Q with a Procession of Children
Zanobi Strozzi ~ c. 1430
Tempera and gold leaf on parchment
A manuscript illumination with the initial
"Q" represents the tradition of the historiated
initial. This is an enlarged letter at the begin-
ning of a paragraph depicting a scene. Gold
leaf was applied to depict the glory of God.

Color Range

1

PMS 877

Note:
CMYK process color cannot
replicate true metallic colors

2

PMS 871

RGB color can simulate a
metallic color as a photograhic
image

Palette Variations

1

PMS	877	C	10	C	0	C	0	C	20
		M	0	M	10	M	25	M	40
		Y	80	Y	100	Y	100	Y	100
		K	0	K	0	K	0	K	0

1

PMS	877	C	75	C	5
		M	30	M	0
		Y	0	Y	0
		K	0	K	0

2

PMS	871	C	0	C	30
		M	100	M	0
		Y	100	Y	100
		K	0	K	60

2

PMS	871	C	70	C	90	C	100	C	0
		M	100	M	100	M	0	M	25
		Y	0	Y	15	Y	100	Y	100
		K	0	K	0	K	30	K	0

2

PMS	871	C	5
		M	0
		Y	0
		K	0

Contributors

Credits

Every effort has been made to trace copyright holders and to obtain their permission for the use of copyright material. The publisher apologizes for any errors or omissions in the above list and would be grateful if notified of any corrections that should be incorporated in future reprints or editions of this book.